cool sites

cool sites

freeze-framed
and down cold

general editor · roger walton

COOL SITES

First published in 1998 by:
Hearst Books International
1350 Avenue of the Americas
New York, NY 10019
United States of America

Distributed in the United States
and Canada by:
Watson-Guptill Publications
1515 Broadway
New York, NY 10036

Distributed throughout the rest
of the world by:
Hearst Books International
1350 Avenue of the Americas
New York, NY 10019

ISBN 0688-16332-7

First published in Germany by:
NIPPAN
Nippon Shuppan Hanbai
Deutschland GmbH
Krefelder Str. 85
D–40549 Düsseldorf
Telephone: (0211) 5048089
Fax: (0211) 5049326

ISBN 3-931884-35-X

Edited and designed by:
Duncan Baird Publishers
75–76 Wells Street, London W1P 3RE
e-mail: roger@dbairdpub.co.uk

Managing Designer: Gabriella Le Grazie
Design: 27.12 design ltd.
Project Co-ordinator: Tara Solesbury
Editor: Clare Richards
Researcher: Fritz Chesnut

10 9 8 7 6 5 4 3 2 1

Typeset in Helvetica Condensed
Color reproduction by Colourscan, Singapore
Printed in Hong Kong

< > When these arrows appear next to page
numbers they indicate that the artwork has been
displayed horizontally rather than vertically.

No web address is given for sites that are no
longer running.

contents

COOL SITES is a status report from the far edge. It is a source of reference and inspiration for those who design, commission, and view websites and an introduction to the aesthetics of websites for members of the digital resistance.

If you want to access the high-water mark of global website design without the 'worldwide wait' – look here.

If you want to gauge the latest 'look' of website design without hours of vdu glare – look here.

If you need to have a source of web design ideas at your fingertips without keyboard interaction – look here.

COOL SITES requires no electricity to view, no software to run, no special training to operate, no large memory, no particular operating platform, no connection to a provider, no downloading time, and no further charge to your credit card.

COOL SITES freeze-frames shifting visual developments in the impermanent arena of digital design, and maps its evolving sophistication and diversity. While live websites change and disappear, **COOL SITES** is a cold-storage record of some of the most creative and provocative work in current digital design.

Browse now.

RW

ice field • promotional work **9**

pages 10–13

title **p2output**

web address **www.p2output.com**

design **Christopher Pacetti, Matthew Pacetti**

design company **p2**

software **bbedit, illustrator, photoshop, sitemill**

number of pages **266**

origin **USA**

type of site **promotion**

work description **an exhibition of work by p2 highlighting projects in print, multimedia, and motion graphics**

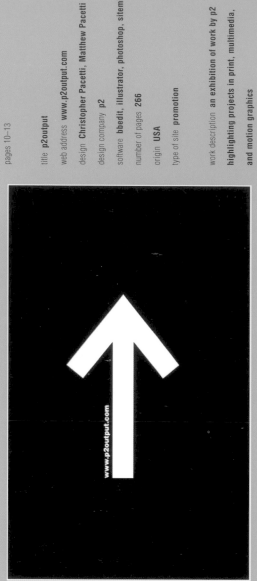

Welcome to **p2 output**,
an exhibition of work by p2.
p2 is a design studio
located in New York City.
Enter to explore the studio's
current portfolio highlighting
projects in print, multimedia
and motion graphics.

(Enter

pages 14–17

title **antirom**

web address **www.antirom.com**

design companies **antirom, tomato (page 16,**
right and page 17, left)

software **bbedit, director 4, sound edit**

origin **UK**

type of site **information**

work description **'open space' art project**

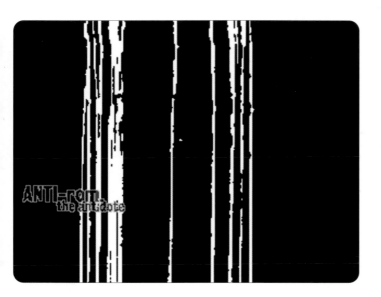

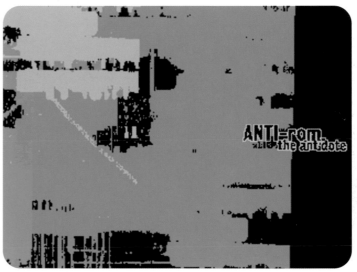

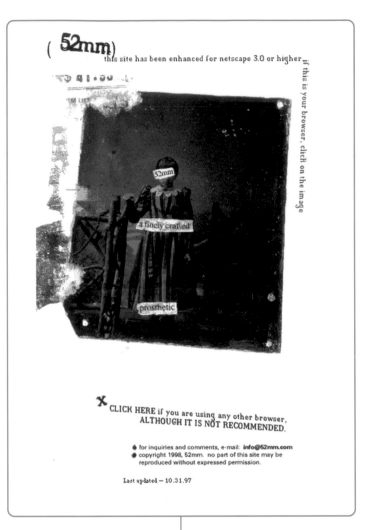

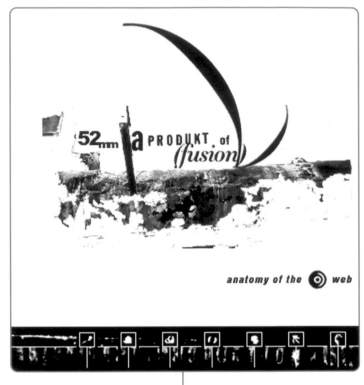

title '**A Finely Crafted Prosthetic**'

web address **www.52mm.com**

design **Marilyn Devedjiev, John J. Hill**

design company **52mm**

software **after effects, bbedit, debabelizer, gifbuilder, illustrator, photoshop**

number of pages **50**

origin **USA**

type of site **promotion**

work description **The 52mm site was developed as online promotion – the most economical form of 'advertising'. Subtle audio enhancement, java script, storytelling, raw digital illustration, and typography are used as vehicles for visual communication. The agenda was to show that technology could never duplicate the ever-expanding realm of human experience, feeling, and spirit.**

info@52mm.com

52mm , a PRODUKT of collision

ron croudy + marilyn devedjiev + john j. hill

jinn@52mm.com

Rtronix@52mm.com typediva@52mm.com

12 John Street, 10th Floor NY, NY 10038-4021

Tel/Fax. 212.766.8035

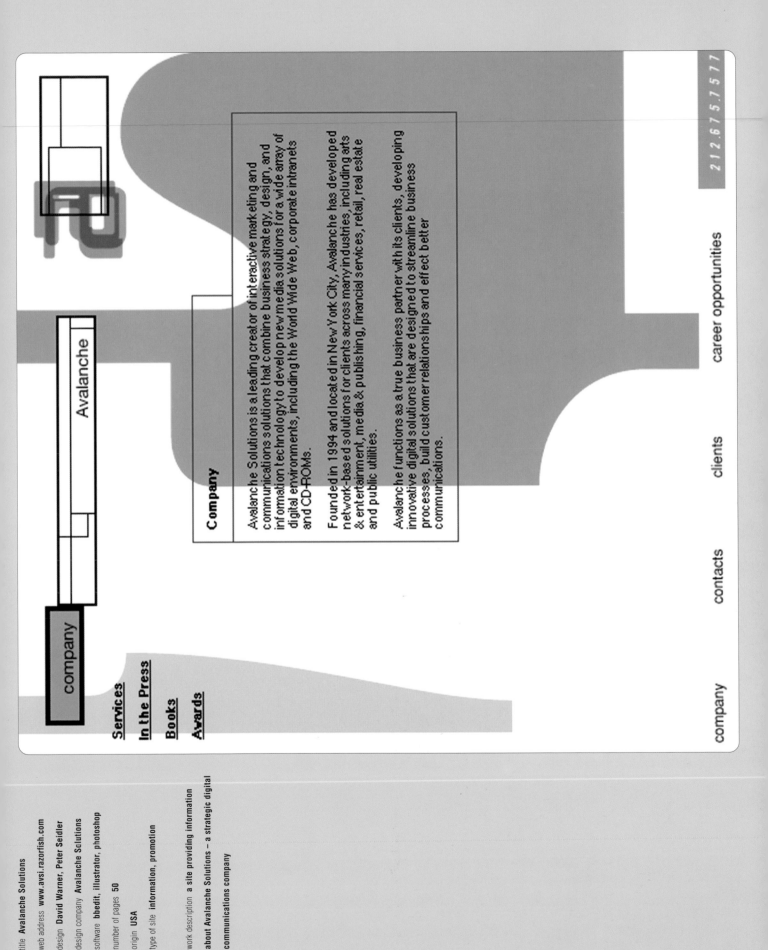

Avalanche

company

Services

In the Press

Books

Awards

Company

Avalanche Solutions is a leading creator of interactive marketing and communications solutions that combine business strategy, design, and information technology to develop new media solutions for a wide array of digital environments, including the World Wide Web, corporate intranets and CD-ROMs.

Founded in 1994 and located in New York City, Avalanche has developed network-based solutions for clients across many industries, including arts & entertainment, media & publishing, financial services, retail, real estate and public utilities.

Avalanche functions as a true business partner with its clients, developing innovative digital solutions that are designed to streamline business processes, build customer relationships and effect better communications.

company contacts clients career opportunities

2 1 2 . 6 7 5 . 7 5 7 7

title **Avalanche Solutions**

web address **www.avsi.razorfish.com**

design **David Warner, Peter Seidler**

design company **Avalanche Solutions**

software **bbedit, illustrator, photoshop**

number of pages **50**

origin **USA**

type of site **information, promotion**

work description **a site providing information about Avalanche Solutions – a strategic digital communications company**

title **Red No. 40 Home Page**

web address **www.red40.com**

design **Jeff Prybolsky, Al McElrath**

design company **Red No. 40**

programming **Al McElrath**

software **bbedit, debabelizer, photoshop**

number of pages **15**

origin **USA**

type of site **information, promotion**

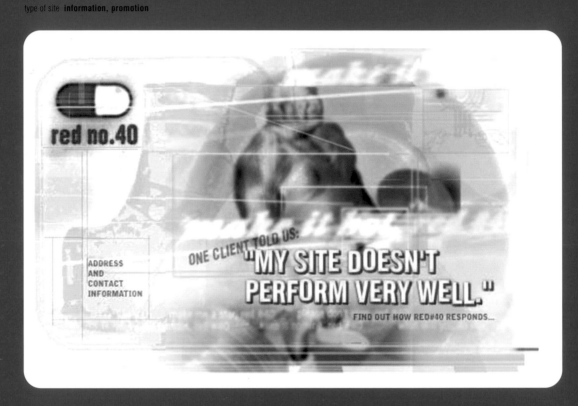

work description **a site promoting the skills of**

Red No. 40 website design company

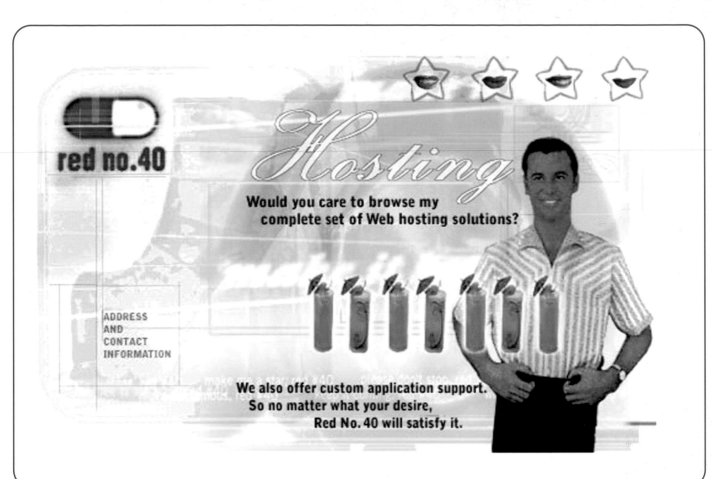

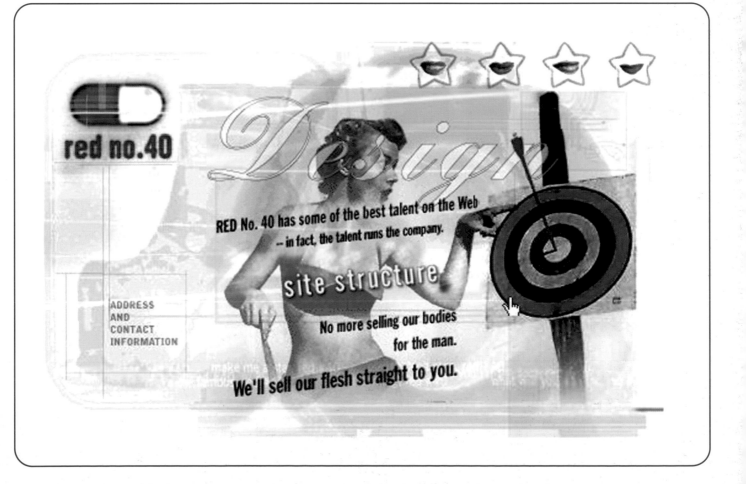

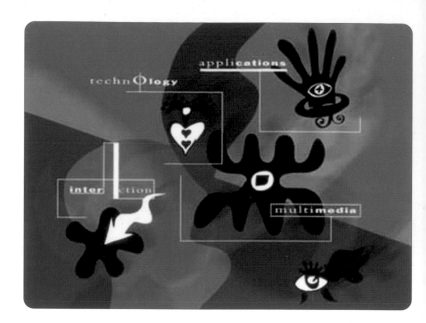

 | Interactiveland

INTERACTIVELAND CD-Rom 1992-3

The interactive provocation, produced to show publishers that the multiple media ways are infinite, is the result of our experimentation ? not the son of the biggest "translating business" of these years: it is an original product, meant to be an interactive application and nothing else, a quest for an original language for these media.

title **Nofrontiere website**

web address **www.nofrontiere.com**

design **Anja Weißbacher, Jo Luik, Tobi Schàfer,**

Christian Reich, Maurizio Poletto, Fritz Magistris

design company **Nofrontiere Design, Vienna**

software **html, perl (for more info see NIFAQ 4)**

number of pages **50**

origin **Austria**

type of site **promotion**

work description **This site is a non-hierarchical presentation of Nofrontiere and parts of their work. Instead of offering pre-made content for visitors to consume like traditional media, the opening section provides a tool that visitors can use to design their own characters, which they can leave at the site for others to see. This is a direct reversal of expectation for a design company's site: Nofrontiere wanted to create an environment that would enable visitors to do the designing. Their first web offering is almost contentless – the visitors develop the content themselves.**

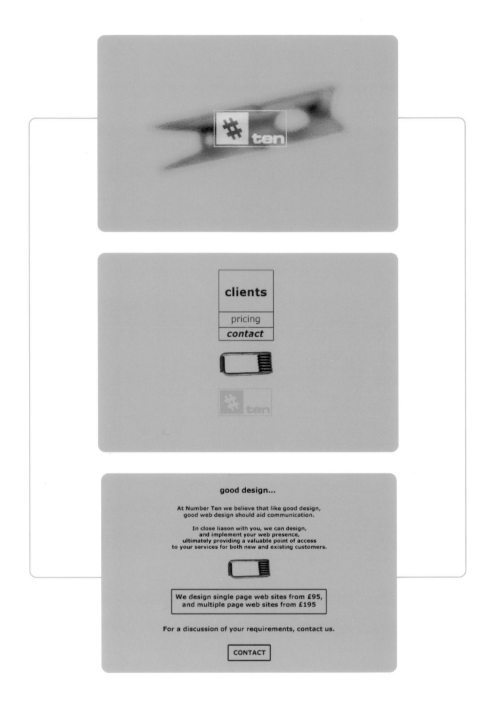

title **Good Design...**

web address **www.ivytech.co.uk/numten**

design **Leigh Dickinson**

design company **Number Ten**

software **dreamweaver, illustrator 7.0,**

pagemill 2.0, photoshop 4.0

number of pages **7**

origin **UK**

type of site **promotion**

work description **a site promoting the services of**

Number Ten web design

IGUANA3
Iguanas Kulturmagasin

start!
Iguanas Rockmagasin

Nick Drake
The Nick Drake Files

Expecting soon

renvall stockholm

title **renvall.se**

web address **www.renvall.se**

design **Mats Renvall**

design company **renvall**

software **bbedit, photoshop 3**

number of pages **10**

origin **Sweden**

type of site **promotion**

work description **a site to promote renvall design**

and share inspirational links

Zoom in: ⌐
Zoom out: ctrl
Drive: hold mouse button down

All fields Studios

Awards
Curriculum vitae
Clients
Publications
Focal areas

Hapo Steffen, born in 1949. Trained with a master
lithographer. Studied at the Werkkunstschule, Dortmund,
qualifying

Self-employed since 1984, producing graphic designs for
services, products and in artistic fields.

Hapo Steffen

Communications design Hapo, Steffen

Hapo Steffen
Ulmenallee 1
44803 Bochum

Telefon 0234 354182
Telefax 0234 350588

title **German Design in Nordrhein-Westfalen 1996/97**

client **Design Zentrum Nordrhein Westfalen**

design companies **Moniteurs, Berlin, Xplicit, Frankfurt**

programming **fünf.6, Berlin**

software **macromedia, quicktime**

origin **Germany**

type of CD-ROM **information, promotion**

work description **This CD-ROM showcases design studios in Nordrhein-Westfalen (photography, product design, graphic design, and multimedia). The user can surf through a virtual space and see a random selection or search for specific designers alphabetically.**

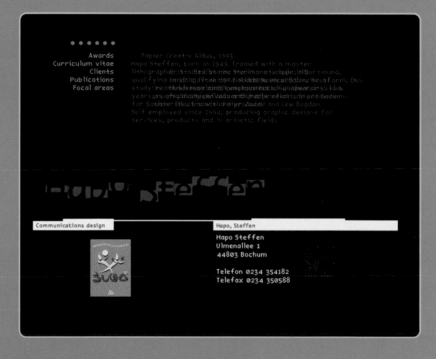

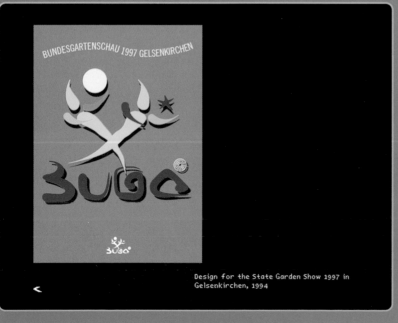

Design for the State Garden Show 1997 in Gelsenkirchen, 1994

title **Blue Brick website**

web address **www.bluebrick.com**

design **Christopher Wise, Tomo Suzuki**

design company **Blue Brick**

software **debabelizer, illustrator, photoshop**

number of pages **3**

origin **USA**

type of site **promotion**

work description **This site provides an overview of design work by Blue Brick, showing pieces of work and their titles with more information available at the user's choice.**

08
1567891011121

walhalla:artforce™

CLICK

walhalla::artforce

ADVERTISINGLAB
FUTUREDESIGN
ARTRESEARCH
CURICULUM
PHILOSOPHY
FURTHER INFOS
MAIL
PROJECTS

walhalla::artforce

title **walhalla artforce**

web address **www.walhalla.ch**

design **Ibrahim Zbat, Marco Simonetti**

design company **walhalla artforce**

software **pagemill 2.0**

number of pages **11**

origin **Switzerland**

type of site **information, promotion**

work description **a self-promotional site for
walhalla artforce, including information about
the company's philosophy, projects, and
interactive dialogue with other artists**

ADVERTISINGLAB

advertisinglab umfasst sämtliche teilbereiche der
integrierten kommunikation. advertisinglab er-
arbeitet massgeschneiderte, auf eine bestimmte
situation oder ein spezifisches zielpublikum
zugeschnittene,innovative lösungen. adver-
tisinglab macht innovative, immer auf ihre
erfolgsopitmierung ausgerichtete werbung.

advertisinglab embraces all partial areas of
integrated communication. advertisinglab works
out taylor-made, innovative solutions, aimed
at or cut out for a particular scene or a
specific public group. advertisinglab, always
conscious of achieving success optimun,creates
innovative advertising

walhalla::artforce

.. Achtung: now entering german netspace.
.. Blauhaus, yeah.

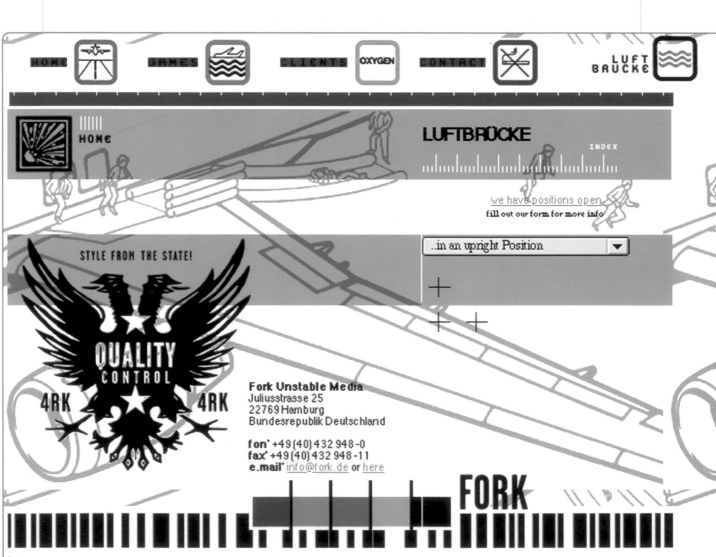

HOME GAMES CLIENTS OXYGEN CONTACT LUFT BRÜCKE

HOME

LUFTBRÜCKE INDEX

we have positions open
fill out our form for more info

..in an upright Position

STYLE FROM THE STATE!

QUALITY CONTROL

4RK 4RK

Fork Unstable Media
Juliusstrasse 25
22769 Hamburg
Bundesrepublik Deutschland

fon +49 (40) 432 948-0
fax +49 (40) 432 948-11
e.mail info@fork.de or here

FORK

HOME GAMES CLIENTS OXYGEN CONTACT

+ CONTACT

OPTIONS AT
THIS LEVEL:

Who is Fork..?

Where is Fork..?

DAVID JEREMY SASCHA ANNE

FORK

title **What is FORK...?**

web address **www.fork.de**

design **Jeremy Abbett, David Linderman**

design company **FORK Unstable Media**

software **bbedit, director, freehand, photoshop,
sound edit 16**

number of pages **40+**

origin **Germany**

type of site **promotion**

work description **This self-promotional site for
FORK design company is based on the plane
safety guide aesthetic, and includes team
member profiles, present and past projects,
continually updated games, and other diverse
distractions.**

title **IN2**

web address **www.in2.com**

design **Bill Moulton**

design company **IN2**

software **bbedit 4.0, gifbuilder, illustrator 7.0,**
photoshop 4.0

number of pages **5**

origin **USA**

type of site **promotion**

work description **a self-promotional site**
for IN2 marketing and design company

IN2

♻

OUR APPROACH
An innovative use of design, technology,
and marketing expertise

CLIENTS
Partnering with the web's leading businesses

PRESS / AWARDS
Adage, Silicon Alley Reporter, Channel Seven

RECENT WORK

Our Approach - Clients - Press / Awards - Recent Work

 40 WEST 27TH STREET NYC NY 10001
212 679 9698

INFO @ IN2.COM

OUR APPROACH
CLIENTS ■
PRESS / AWARDS
RECENT WORK

CLIENTS

These clients represent some of the most progressive companies on
the internet. In all cases, IN2 has been an important partner in the
continued growth and success of these businesses on-line.

- iVillage
- America Online
- N2K (Music Boulevard)
- Simon & Schuster
- New Line Cinema
- Ziff Davis
- Hasbro / Kenner
- Quick & Reilly
- Lycos

NEXT SECTION ►

Home - Contact IN2

 40 WEST 27TH STREET NYC NY 10001
212 679 9698

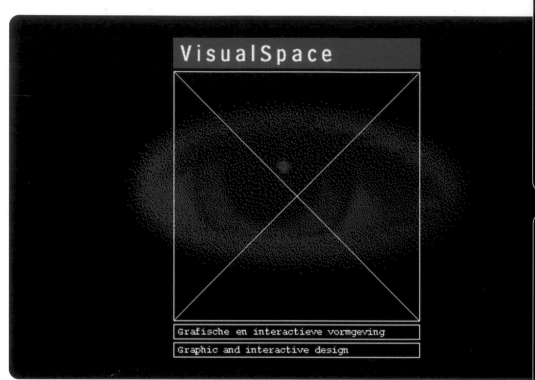

title **VisualSpace**

web address **www.xs4all.nl/~vspace.nl**

design **Kees van Drongelen, Nina de Vrind**

design company **VisualSpace**

software **bbedit, debabelizer, photoshop**

number of pages **70**

origin **The Netherlands**

type of site **information, promotion**

work description **a self-promotional site for VisualSpace design company**

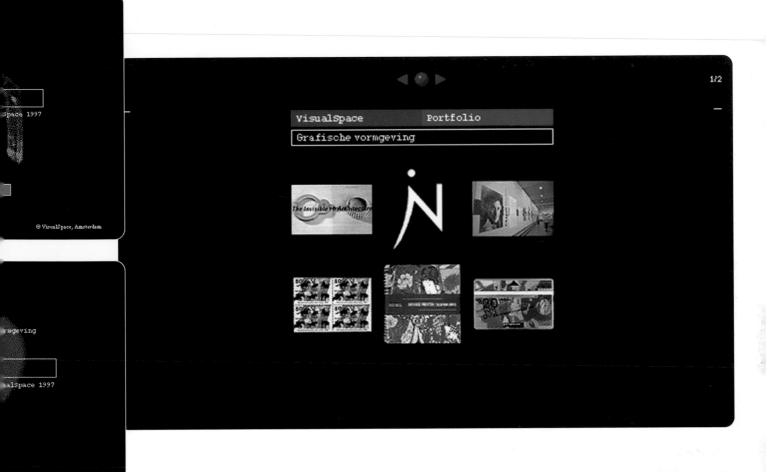

title **Akimbo Design website**

web address **www.akimbodesign.com**

design **Ardith Ibañez Rigby, Doria Fan**

design company **Akimbo Design**

software **bbedit, flash 2, freehand 7, homesite, photoshop 4**

number of pages **18**

origin **USA**

type of site **promotion**

work description **This site showcases Akimbo's work for fans and potential clients; providing information about the company, its philosophy, services, awards, publications, events, and contact information. Each design project has a page of thumbnails and text describing the designs and the web technology used.**

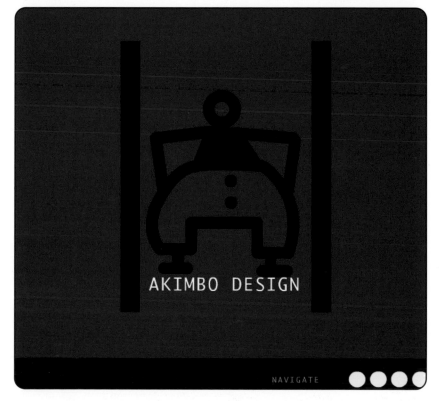

AKIMBO DESIGN

NAVIGATE

title **SuperFly Fashions**

web address **www.dhtmlzone.com/tutorials**

client **Macromedia, Inc.**

design **Ardith Ibañez Rigby**

design company **Akimbo Design**

programming **Benjamin Rigby**

software **dreamweaver, freehand 7,**
gifbuilder, homesite, illustrator 5.5,
photoshop 4

origin **USA**

type of site **education**

work description **Macromedia wanted an**
exciting site to showcase dynamic html
technology for their new DHTML zone site.
Akimbo created a website for a mock
clothing company, SuperFly fashions,
complete with a catalog, an outfit
planner, and a dressing room. At any point
within the site, visitors can click on the
tutorial button to learn how that particular
section was created.

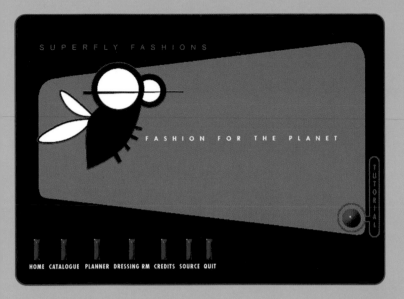

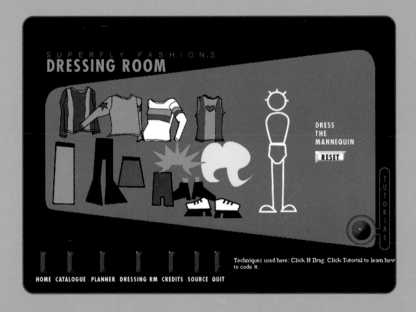

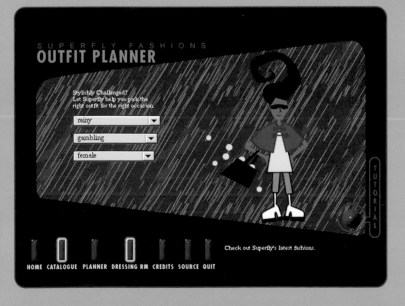

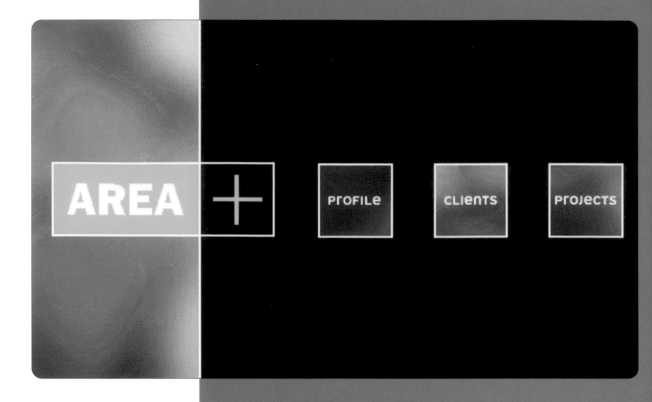

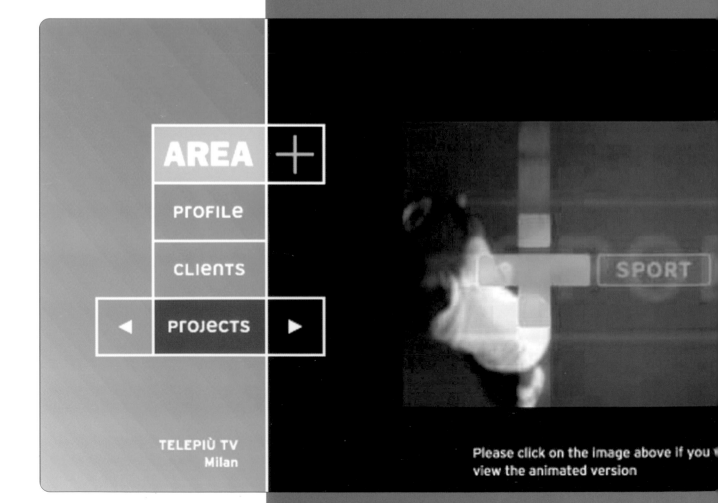

TELEPIÙ TV
Milan

Please click on the image above if you w
view the animated version

Studio 3A, Leroy House, 436 Essex Road, London N1 3QP
Tel: +44 (0)171 354 0609 Fax: +44 (0)171 354 5391
Email: area@area.demon.co.uk

This site uses a family of fonts designed in conjunction with
Hubert Jocham for Telepiù TV, Milan, as part of their corporate
identity scheme

title **AREA+**

web address **www.area.co.uk**

design **Cara Gallardo, Richard Smith**

design company **AREA**

software **freehand, homepage, pagemill,**

photoshop

number of pages **28**

origin **UK**

type of site **promotion**

work description **an online portfolio for AREA**

design company, including experimental personal

projects

title **Giant Step website**

web address **www.giantstep.com**

design **Xavier Wynn, Sheau Hui Ching,**
Sean Moran, Melisa Vazquez (art direction),
Gregory Galloway (art direction)

design company **Giant Step**

programming **Kerry O'Donnell**

software **debabelizer, illustrator, internet studio,**
photoshop

origin **USA**

type of site **promotion**

work description **The Giant Step site showcases the**
company's work and presents a broad spectrum
of their capabilities to attract potential clients
and prospective employees. Built upon the
intrinsic qualities of growth, creation, and
organic form, the site begins with the company
logo on the splash screen. On the subsequent
homepage, the logo is 'planted' on the page, with
the main areas of the site (clients, contact, press,
jobs, and links) appearing underground.
The client section of the site is dynamically
presented in one of two versions, depending on
the browser: Internet Explorer users experience
an interactive timeline utilizing an activex
control, while Netscape users view client
information accessible through a left-to-right
display of client logos.

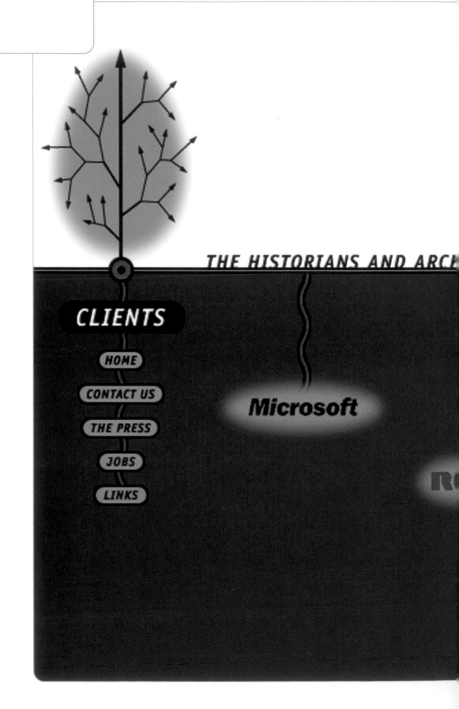

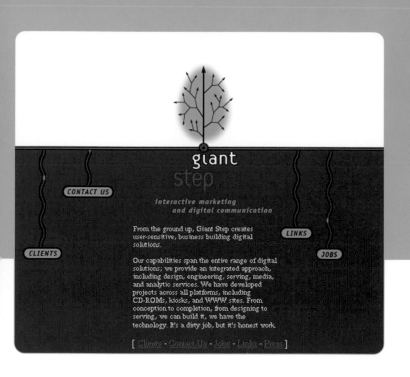

GISTS WILL ONE DAY DISCOVER THAT THE ADS OF OUR TIMES ARE THE RICHEST

work description **The concept for this award-winning third generation website was to break away from traditional company portfolio homepages. It is an experimental playground demonstrating the latest internet technologies, including animation, streaming audio, shockwave, java, vr, etc. The core of the site is 'Lemonscape' which uses java technology to replace Netscape's browser interface with the Lemon browser.**

title **Lemon**

web address **www.lemon.com.hk**

design **David Mok, Chris Potter, Everett Rodriguez**

design company **Lemon**

software **bbedit, electric image, freehand, photoshop, premiere**

number of pages **30**

origin **Hong Kong, China**

type of site **promotion**

lemon

Lemon is an interactive multimedia agency, specialising in creating Internet web sites.

We deliver cutting-edge design and technology, driven by intelligent strategic thinking, helping you develop new media business and marketing solutions.

The Internet -

The **ultimate**

organic manifestation

of our

collective **consciousness**

Human **Evolution**

is now inextricably **bound up** with

Technological
Evolution

We have the
TECHNOLOGY

Web sites are not just electronic corporate brochures. Companies all over the world are harnessing this new technology to add value to their services, create new products, and make themselves more competitive in the global market place.

we can him...
REBUILD

title **Stylorouge – Perestroika 98**

web address **www.stylorouge.co.uk**

design **Julian Quayle, Robin Chenery**

design company **Stylorouge**

programming **Motion Pixels**

software **illustrator 7.0, photoshop 4.0**

number of pages **66**

origin **UK**

type of site **promotion**

work description **These initial designs are proposals for a re-vamp of the existing Stylorouge website. Apart from presenting an online portfolio, Perestroika is intended to be factual and enjoyable: to provide Stylorouge's history and structure and to reveal something of the company's personality through the exposure of their creative disciplines.**

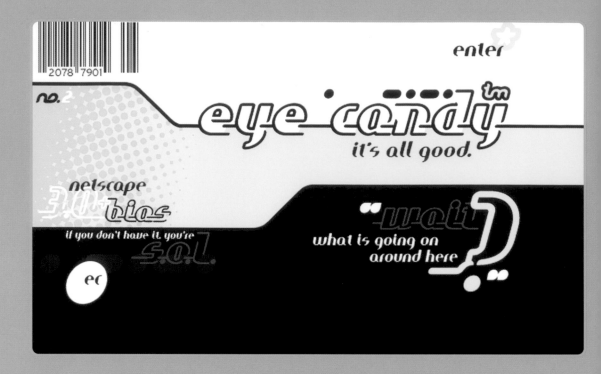

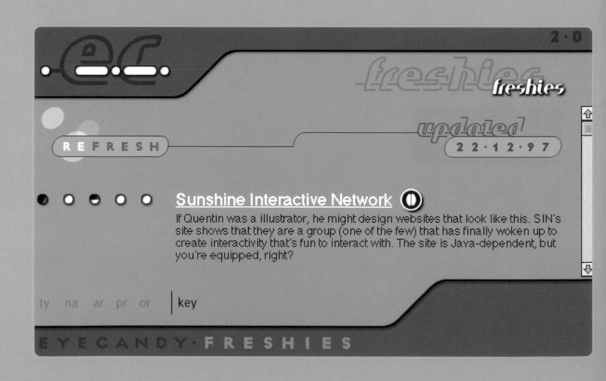

i want my eye candy.

EYECANDY

title **Eye Candy**

web address **www.eyecandy.org**

design **Josh Ulm**

software **bbedit, photoshop**

origin **UK**

type of site **information, promotion**

work description **Eye Candy is an online resource for new media designers to examine the state of the web and the leading edge websites that are changing the way people communicate on the internet. It connects users to some of the most radical designs and experiments being created by the industry's top online designers and design companies.**

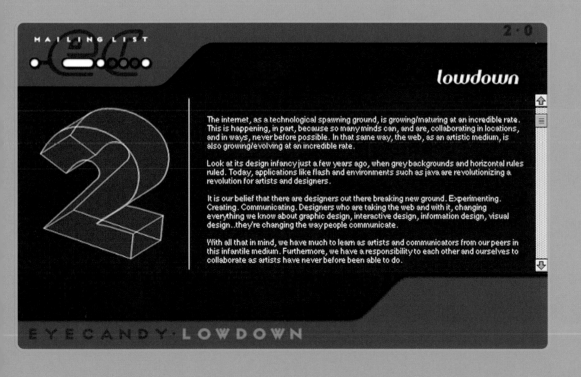

MAILING LIST

lowdown

The internet, as a technological spawning ground, is growing/maturing at an incredible rate. This is happening, in part, because so many minds can, and are, collaborating in locations, and in ways, never before possible. In that same way, the web, as an artistic medium, is also growing/evolving at an incredible rate.

Look at its design infancy just a few years ago, when grey backgrounds and horizontal rules ruled. Today, applications like flash and environments such as java are revolutionizing a revolution for artists and designers.

It is our belief that there are designers out there breaking new ground. Experimenting. Creating. Communicating. Designers who are taking the web and with it, changing everything we know about graphic design, interactive design, information design, visual design..they're changing the way people communicate.

With all that in mind, we have much to learn as artists and communicators from our peers in this infantile medium. Furthermore, we have a responsibility to each other and ourselves to collaborate as artists have never before been able to do.

EYECANDY·LOWDOWN

Services

History

Folio

Email

title **ACROBATIX website**

web address **www.acrobatix.co.uk**

design **Mark Thornicroft**

design company **ACROBATIX**

programming **Nick Fallon**

software **freehand, frontpage, photoshop,
quarkxpress**

number of pages **55**

origin **UK**

type of site **promotion**

work description **an online portfolio for ACROBATIX
design consultants**

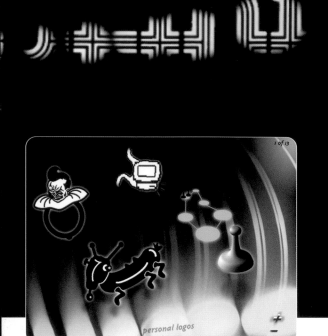

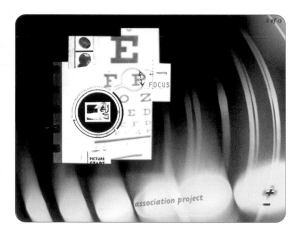

title **Self-Promotional CD-ROM**

design **Dave Bravenec**

design company **Dave Bravenec Design**

software **director, illustrator, photoshop**

number of pages **16**

origin **USA**

work description **This interactive director piece
highlights, in digital format, work samples that
were originally done as analog pieces.
The CD-ROM was created to fit a large quantity of
work on to a smaller format to show clients.**

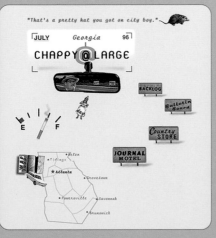

title **Chappy@large**

web address **www.hob.com/chappy**

client **Sun Microsystems, Java Joint**

design **Dave Bravenec**

design company **HOB New Media**

software **illustrator, photoshop, premiere**

number of pages **200**

origin **USA**

type of site **information**

work description **This site documents the travels of Chappy, a fictional character who roamed the backroads of Georgia during the '96 olympics, seeking out the unusual and the offbeat. Visitors could contact him and keep up with his mishaps as they happened day by day.**

CHARGE

IN THE NETWORKED ECONOMY
YOU ARE YOUR RELATIONSHIPS
THE SUCCESS OF OTHERS IS YOUR SUCCESS
YOUR SUCCESS IS OUR GOAL

EO lands at Vodaworld
03 - 02 - 1998

Vodaworld, the new cutting edge one-stop Vodacom service complex in Midrand, has selected Electric Ocean to head up the development of its multimedia environments.

The first phase of the project was be unveiled at the opening of Vodaworld on 6 March 1998. Electric Ocean will develop new materials for release at Vodaworld on an ongoing basis. The team includes strategic planner Jason Probert, executive producer Quentin George, creative director Nicholas Wittenberg, John George and graphic designer Adam Stone.

Caltex Oil South Africa
A crisp, clean interface guides viewers through the site, offering a wealth of motoring tips and information, including maps of major South African road routes, a virtual tour of Caltex's community development projects and a petrol price predictor. the site also seeks to build brand loyalty by allowing users to subscribe to regular newsletters on a variety of motoring related topics.

Cape Fruit
In sizing up to the deregulation of the deciduous fruit industry Unifruco set out to cement its relationships with international importers and retailers through a web site offering up to the minute information about varieties available. The site also provides a health service and general information to the consumer, learning and fun activities for children and teaching aids for South African teachers in a special kids' section "kidding about".

Webcast
A cross web/TV production. EO produces a weekly TV insert (screened on SABC3) and a weekly updated web site to coincide with the screening. This TV web integration showcases a topical interview, a tour of interesting web sites and an opportunity for viewers to interact with the show's host and each other. This style of integrated production is where EO sees its future.

wired **top 20**
by jason probert

south africa still in the 'wired' top twenty

South Africa is still one of the largest markets on the Internet, but it's losing ground to countries who are fast catching on to the digital wave.

According to the latest biannual domain name survey conducted by Network Wizards, the South African domain of the Internet (all addresses ending with .za) has 122 025 computers connected, and has grown by less than four percent over the last six months. With growth of less than 19 percent over the first six months of last year, that means that the South African Internet grew by only 23 percent during 1997. During 1996, the .za domain grew by 105 percent.

Taiwan has been the big mover over the last six months, more than trebling the number of Internet hosts from 40 000 in July last year to nearly 180 000 today, and leapfrogging from 30 to 13 on the list.

New Zealand has been the other big mover. A year ago New Zealand had fewer Internet connections than South Africa, but they have doubled in size so that today — with 169 264 internet hosts –the .nz domain has 40% more Internet connections than .za.

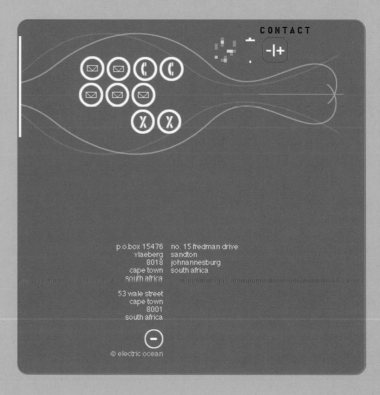

CONTACT

p.o.box 15476 no. 15 fredman drive
vlaeberg sandton
8018 johannesburg
cape town south africa
south africa

53 wale street
cape town
8001
south africa

© electric ocean

title **Electric Ocean website**

web address **www.electric.co.za**

design **Nicholas Wittenberg, Stephen Garratt**

design company **Electric Ocean**

software **bbedit, freehand, photoshop**

number of pages **4**

origin **South Africa**

type of site **promotion**

work description **This showcase of Electric Ocean's web design work is targeted at potential customers committed to building brands online.**

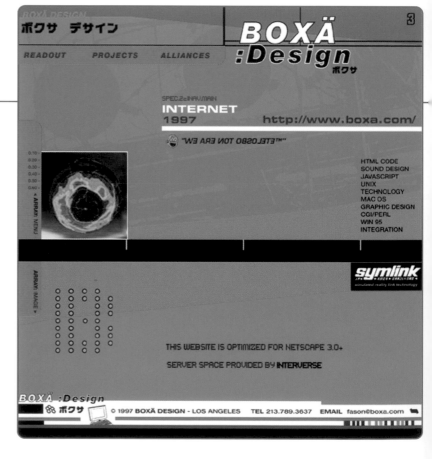

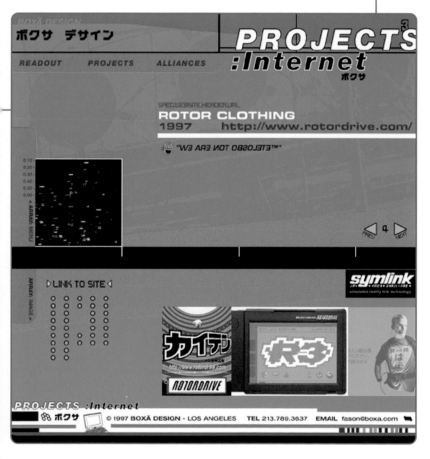

title **BOXÄ website**

web address **www.boxa.com**

design **Jason Fields**

design company **BOXÄ Design**

software **bbedit 4.0, illustrator 7.0, photoshop 4.0**

origin **USA**

type of site **promotion**

work description **This self-promotional web space provides an illustration of BOXA's design aesthetic and a method for prospective clients to reference recent works and creative alliances.**

büro ——— destruct ———

ビュロ デストラクト

we are not a company
we are not an agency
we are not a firm
but we are a small and
friendly graphic design studio
which can be permissioned
by good clients with good
products and nice budgets
of course...

[newz] [music opticals] [gymnastics] [bd fonts] [bd rom] [qtvr visit] [DDD]
[gimmicks] [wintertime on mars] [guestbook] [publications] [links] [mail]

31March98
made in büro destruct berne capital switzerland

Arbeitsplatz im BD!

BB CONSOLE

ABCDEFGHIJKLMNOPQRSTUVWXYZ
ABCDEFGHIJKLMNOPQRSTUVWXYZ
1234567890¢£?ÄÖÜßÀÁ
:.,- @

SET YOUR CONSOLES NOW

electrobazar rue 48

title **büro destruct**

web address **www1.bermuda.ch/bureaudestruct**

design **Lopetz, Daniel Schüler, Heiwid**

design company **büro destruct**

software **fetch, gifbuilder, illustrator, irix, linux,
photoshop, simple text, s.u.s.e., vi**

number of pages **85**

origin **Switzerland**

type of site **promotion**

work description **a self-promotional website for
büro destruct design company**

title **BD ROM**

design **Lopetz, Heiwid, Pedä, MBrunner, H1**

design company **büro destruct**

programming **Michael Bäehni, Daniel Ihly**

software **director, illustrator, photoshop**

origin **Switzerland**

type of CD ROM **promotion**

work description **a self-promotional digital
showreel of büro destruct's design work**

title **Eg.G website**

web address **www.eg-g.com**

design **Dom Raban**

design company **Eg.G**

software **bbedit, gifbuilder, illustrator, photoshop**

number of pages **14**

origin **UK**

type of site **promotion**

work description **a self-promotional site for Eg.G**
design company

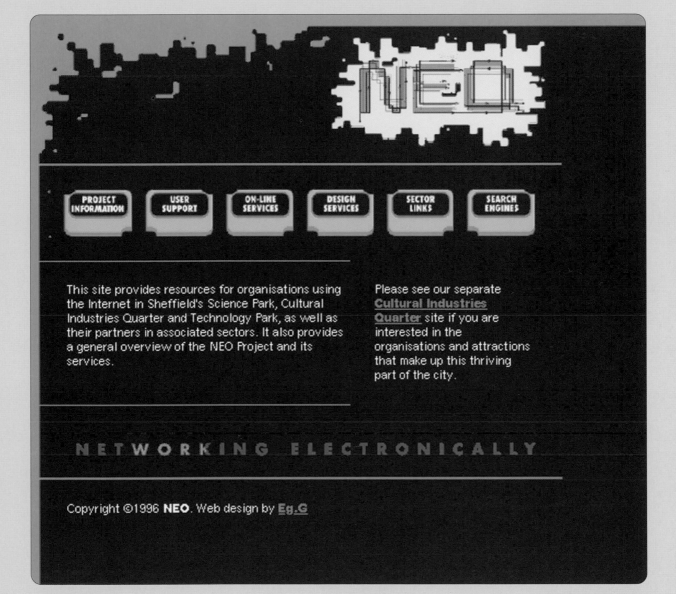

NETWORKING ELECTRONICALLY

Copyright ©1996 **NEO**. Web design by **Eg.G**

title **NEO website**

web address **www.fdgroup.co.uk/neo**

client **NEO**

design **Dom Raban**

design company **Eg.G**

software **bbedit, gifbuilder, illustrator, photoshop**

number of pages **12**

origin **UK**

type of site **information**

work description **This site enables NEO customers to access details of online discussion services, receive support for using the internet and designing web pages, and obtain web links in their creative sectors. For the casual browser the site also provides an overview of the NEO project.**

A NEW BREED AD AGENCY

Digital Pulp communicates. Through strategy. Words. Graphics. Technology. As a new breed ad agency we focus on both new and traditional media. We create impressions.

CLICK HERE FOR NANO-SITE™
WE ARE HIRING.

→← *DIALOG* + *SERVICES* = *SOLUTIONS* ✿ *PHILOSOPHY* ✕ *DPTECH* e^2 *EXPERIMENTS*

Digital Pulp Inc.
220 East 23rd Street, Suite 1007, New York, N.Y.10010 212.679.0676
©1998 Digital Pulp Inc.

title **Digital Pulp website**

web address **www.digitalpulp.com**

design **Bruce Goodman, David Ormes**

design company **Digital Pulp, Inc.**

software **debabelizer, illustrator, photoshop 4.0**

number of pages **50**

origin **USA**

type of site **promotion**

work description **This site promotes the services and experience of Digital Pulp, Inc., an interactive advertising agency.**

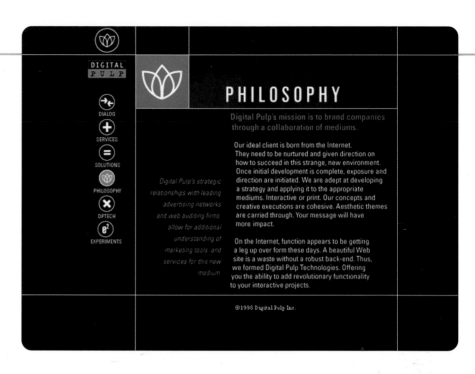

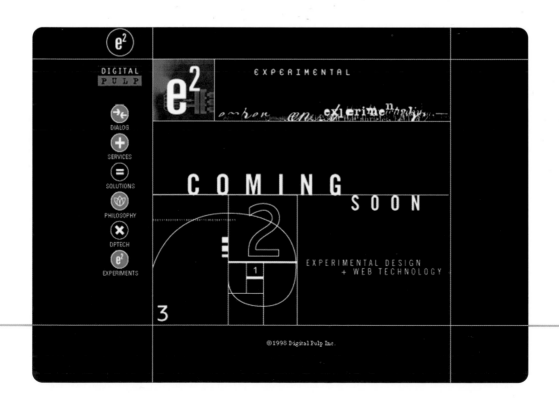

Launch Tuesday February 3. 1998 Tusenårsskiftet – Norge 2000.

title **Union Central**

web address **www.uniondesign.com**

design company **Union Design**

software **bbedit, illustrator, jet, pagemill,**

photoshop, strata studio

number of pages **200**

origin **Norway**

type of site **promotion**

work description **a site providing information**

about Union Design to clients and the design

community

title **Spinning Jenny**

web address **www.home.earthlink.net/~zannstarr8**

design **Jennifer Staggs**

software **director, gifbuilder, illustrator, morph, photoshop, screenready, webweaver**

number of pages **25**

origin **USA**

type of site **promotion**

work description **a self-promotional website, compiled upon graduation from CalArts, to give potential employers easy access to an online portfolio**

[**MULTIMEDIA** | **PRINT** | **PROCESS** | **SITE INFO** | **LINKS**]

PROCESS

methodfive

001 ¬ W38 D3V3LoPM3N7 ¬ D351gN ¬ M37HoD 5

Lo9o ¬

title **methodfive**

web address **www.methodfive.com**

design **Chris Garvin, Ramon Bloomberg**

design company **methodfive**

software **bbedit, gifbuilder, photoshop 4.0**

number of pages **50**

origin **USA**

type of site **information, promotion**

work description **a self-promotional site for methodfive web development company**

depart >> myriadagency | arrival >> methodfive

1 company
2 clients
3 services
4 news
5 contact

Our Latest: Life-line.org

methodfive goes international

Job Opportunities @ methodfive

*method*five

632 broadway tenth floor. new york. ny 10012. | tel: 212.539.0900 | fax: 212.539.0100 | info@methodfive.com

company

010 ¬ CoMP4NY ¬ M37Hod 5

Welcome

methodfive is a top-tier provider of Internet development and production services. We create elegant and innovative solutions to a wide range of Internet design, technology, and marketing challenges. methodfive offers exceptional performance and a history of fruitful, long-term relationships with a growing list of distinguished and discriminating clients.

1 . 2 . 3 . 4

*method*five | company | services | clients | news | contact
info@methodfive.com | tel :: 212.539.0900 | 001 ¬ W38 D3v3LoPM3N7 ¬ M37HoD 5

who what why how

MEDIUM RARE

41 clink street studios
clink street
london
se1 9dg

t: 0171 403 3395
f: 0171 378 7154
e: studio@mediumrare.net

MEDIUM RARE

[who we are]

Mediumrare was formed in 1996 after a long collaboration between three specialist business's spanning ten years, Plastic Fir one (multimedia programming & production), BBD Communication (design project management), Nouyou Design (graphic / interactive design).

It is a progressive design company creating and implementing graphic design concepts to work in on-screen environments and printed media, using multimedia and interactivity as essential tools for delivering on screen information and design excellence throughout printed and screen work.

Understanding the technology, delivery platforms and production values that are involved, Mediumrare ensures client information is delivered in a form that the viewer / reader will feel at ease with so making them receptive to

MEDIUM RARE
>>CD ROM
Globe Cast Northern Europe

title **Mediumrare.net**

web address **www.mediumrare.net**

design **Christian Nouyou, Sarah Yeh**

design company **Mediumrare**

software **bbedit, gifbuilder, photoshop, webmap**

number of pages **40**

origin **UK**

type of site **promotion**

work description **This self-promotional site for mediumrare, a multimedia design company, provides users with a flavour of the company's work, for corporate and entertainment clients, without visual or technological overkill.**

title **NoHo website**

web address **www.noho.co.uk**

design **Howard Dean, Kevin Hankey, David Hurren (art direction), David Hughes (html), Nigel Harris (sound)**

design company **NoHo Digital Ltd.**

software **flash 2.0**

number of pages **200+**

origin **UK**

type of site **promotion**

work description **This site serves as a constantly evolving showcase for NoHo's work, and provides a channel through which they can communicate with clients.**

NoHo Digital Limited

MINDGYM

GO HOME

In association with Melrose Film Productions, NoHo Digital's award-winning interactive CD-ROM, MindGym, was the talk of Milia '97. In the way that only multimedia can, MindGym presents the user with a series of logistical and aesthetic problems designed to increase creativity and practicality in both business and social spheres.

With an hilarious trainer who'll both tease and bully, MindGym uses elaborate animation, design and atmospheric soundscapes in a series of skill-forming, funny and offbeat exercises: from 'Is a brick wall a problem?' to 'How to promote world peace with a cucumber?' , MindGym is a truly unique experience designed to improve mental fitness.

PRODUCTS

NOHO

PLAY DEMO ▶▶

2 litres =
how many...*pints?*

(a couple)
2 litres =
how many...*pints?*
(A) **2.5**　*(B)* **3.5**　*(C)* **4.5**

CHALLENGE
2 litres = 3.5 pints
(c) 4.5

NOHO
"It's North of SoHo"

work description **The Xnet site was started by a group of friends with a passion for computer graphics and is used for experiments in graphic design and interactivity; it also acts as self-promotion for the creators, who are all graphic or interface designers.**

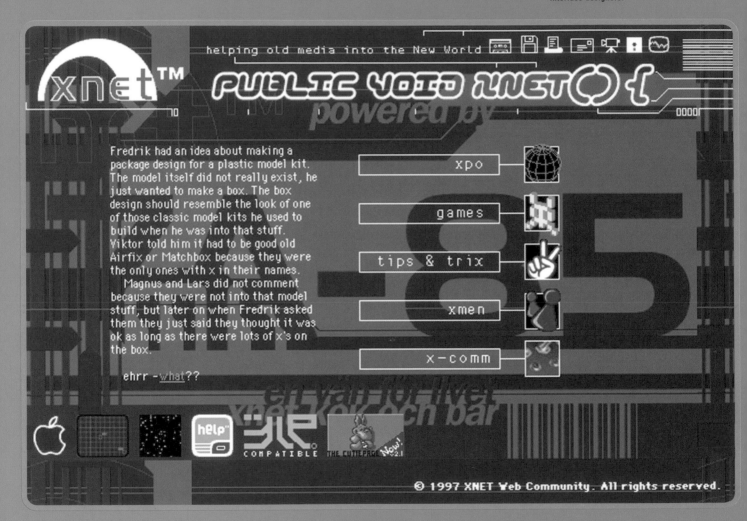

title **Xnet**

web addess **www.xnet.se**

design **Lars Jansson, Viktor Larsson,**

Fredrik Josefsson, Magnus Alm,

Martin Cedergren

design company **Xnet**

software **cinema 4d, deluxe paint, director, flash,**

formz, illustrator, photoshop, teachtext

number of pages **60**

origin **Sweden**

type of site **information, promotion**

XNET™ GAMES

NETGEMS™
netGems™ a game
about monsters,
mazes and diamonds.
40k large, shock-
wave plugin needed.

TRASH!
Trash is an enviromental
game about collecting
garbage. Shockwave, 200k.

jPong™
Plug in this
cassette to play
jPong. You need
a java enabled
browser.

plugin
tech.

type:cdev COMM. SENSE™

After the one player chat
module broke down, the xmen
went looking for a more
glue-resistant in/out
hardware solution. The result
was the Xnet Communication
Device, a machine not only
capable of having multiplayer
chat sessions with the xmen,
but also capable of handling
the long-awaited Xnet News
section. The Guestbook
Community have also adapted
well to their new environment
thanks to the X-fade
technology. The email option is
still found in the xmen area.

xnet news
chat
guestbook

ice floe • commercial work **83**

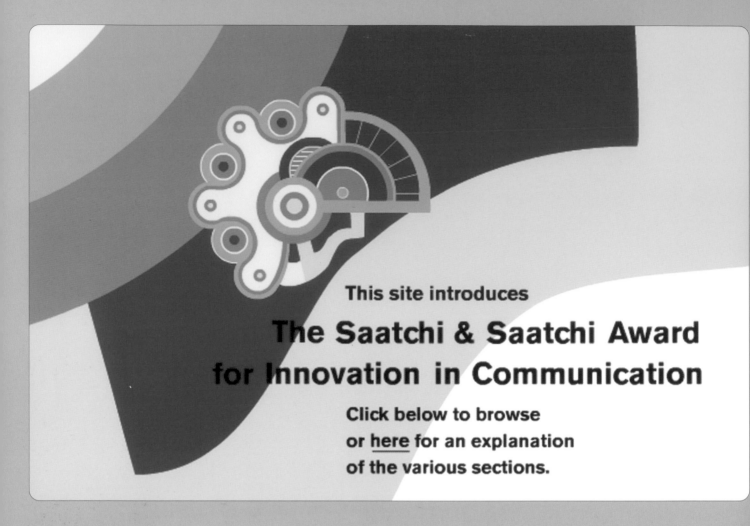

This site introduces

The Saatchi & Saatchi Award for Innovation in Communication

**Click below to browse
or here for an explanation
of the various sections.**

about
the award

eligibility

how to
enter

guidelines

judges

terms and
conditions

This is the field of communication technology.

title **The Saatchi & Saatchi Award for Innovation in Communication**

web address **www.saatchi-saatchi.com**

design companies **AMX Digital, Saatchi & Saatchi**

software **real video, shockwave flash, streamed shockwave audio**

number of pages **60**

origin **UK**

type of site **information, promotion**

If one fundamental change in the human condition holds out the promise of a better, fairer, more enlightened future, it is the connectedness of modern citizens; to each other and to an almost unlimited amount of information and news.

continue

Growing, not only through our own input but through yours too.

HI, LO, OR NO
The idea can be hi-tech, lo-tech or no-tech at all.

work description **This site promotes the first global award for innovation in communication, run by the self-styled 'ideas' company Saatchi & Saatchi.**

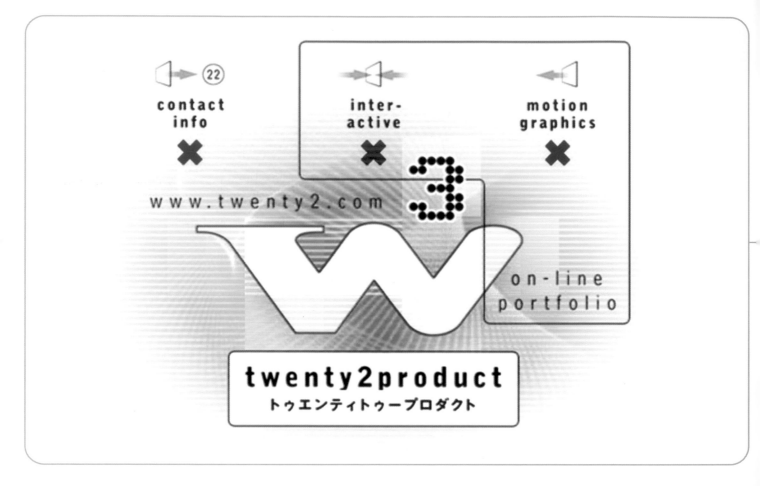

title **twenty2product www 2.4**

web address **www.twenty2.com**

design **Nori Tolson, Terry Green**

design company **twenty2product**

software **photoshop 4.0.1**

number of pages **5**

origin **USA**

type of site **information, promotion**

work description **a self-promotional site to**
familiarize potential clients with twenty2product's
work and provide them with contact information

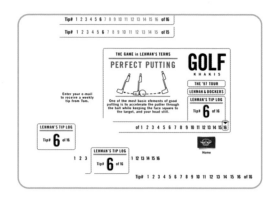

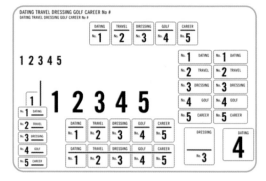

title **Dockers / Dockers Golf**

client **Levi Strauss / Phoenix Pop Productions**

design company **twenty2product**

software **illustrator, photoshop**

origin **USA**

type of site **information, promotion**

work description **a site communicating the Dockers product line, fashion advice for men, and basic golfing techniques**

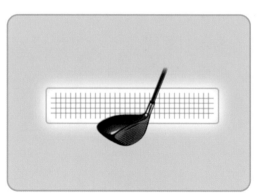

hewlett•packard
international women's cycling

title **HPIWC (development)**

web address **www.hpiwc.com**

client **Winkler Advertising / Phoenix Pop Productions**

design company **twenty2product**

software **illustrator, photoshop**

origin **USA**

type of site **promotion**

work description **The HPIWC (Hewlett-Packard International Women's Cycling) racing event site outlines participant biographies, course statistics, and race results.**

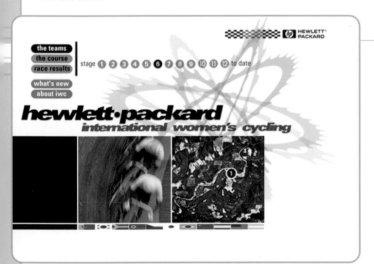

title **NEC Global website**

web address **www.nec-global.com**

client **NEC Japan / Jane Hall Productions**

design company **twenty2product**

software **illustrator, photoshop**

origin **USA**

type of site **information**

work description **This site serves as an index to all NEC local sites and online services.**

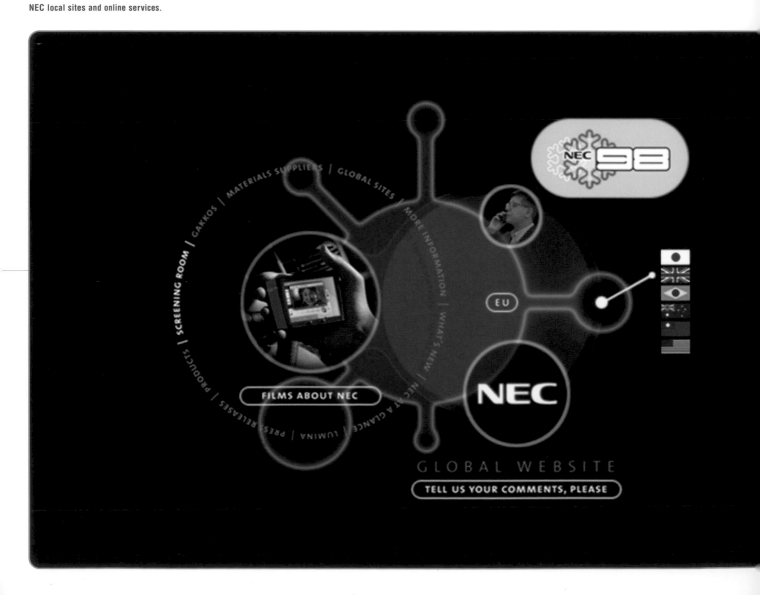

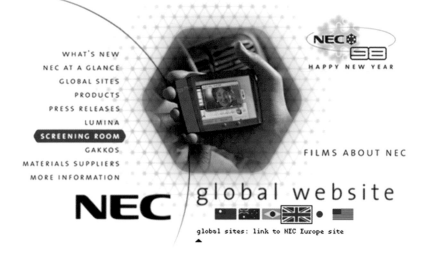

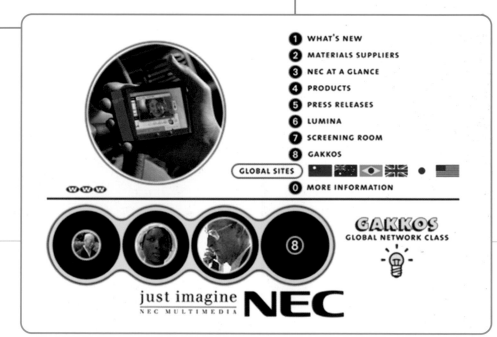

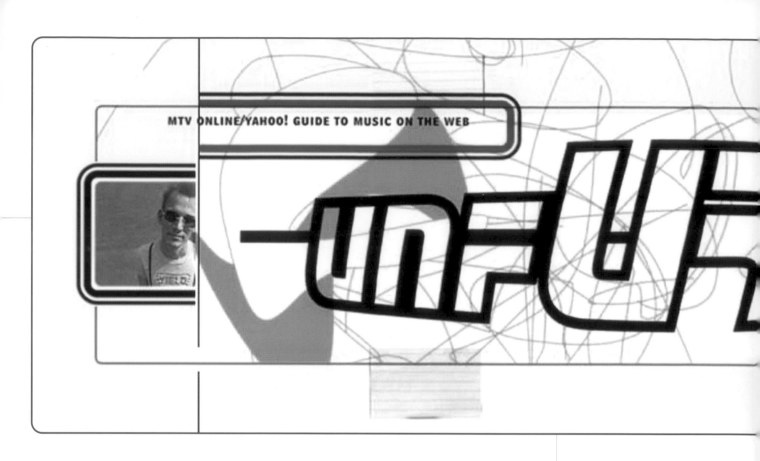

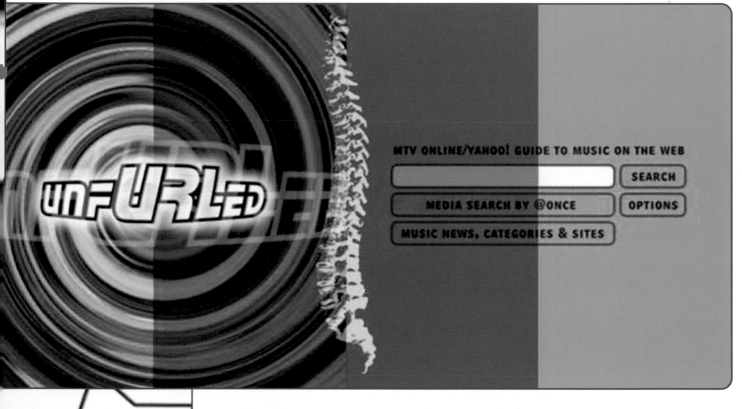

MTV ONLINE/YAHOO! GUIDE TO MUSIC ON THE WEB

SEARCH

MEDIA SEARCH BY @ONCE OPTIONS

MUSIC NEWS, CATEGORIES & SITES

title **unfURLed development**

client **MTV, Yahoo!**

design **twenty2product**

software **illustrator, photoshop**

origin **USA**

type of site **information**

work description **a search engine for music sites,
also featuring music industry gossip, user
surveys, and competitions**

SilverApplesDJTimGaneSneakster

title **SCRATCH (17 & 18)**

web address **www.dfuse.com/scratch**

client **SCRATCH**

design **Jon @ The Forss**

design company **D-FUSE**

software **bbedit, photoshop**

number of pages **10+**

origin **UK**

type of site **promotion**

work description **This site, based on SCRATCH's monthly club flyer design, allows browsers to keep up to date with forthcoming club events.**

Thur16OCT/97

SCRATCH

**DJVadi
m+A-
Cyde/D
JHand
sdown
/Simo
nHopk
ins/Da
nielPe
mbert
on**

**Elixir
(Langua
ge)**

**DJTon
yThorp
e**(Langu
age)

7-12pm
The
Spitz,
109
Comme
rcial
Street,
Spitalfie
lds
Market,
London
E1, UK.
Liverpo
olStreet/
Aldgate
East
Tubes
£6 (£4
concs).
Booking
+44
(0)171
247
9747
Info: +44
(0)171
228
6616. E-
mail
Scratch.
Cheap
Bar &
Food
Gallery
Visuals
by D-
Fuse
ISDN
Brooks
WasHer
eDesign
:Jon@..
The
Forss

D-FUSE

LEAF WIRE

title **Mental Groove Records website**

web address **www.mgroove.com**

client **Mental Groove Records**

design **Laurent Iacazzi**

software **homepage, notepad, realaudio**

number of pages **55**

origin **Switzerland**

type of site **information, promotion**

work description **a site promoting the records and parties of Mental Groove Records and other labels in Geneva**

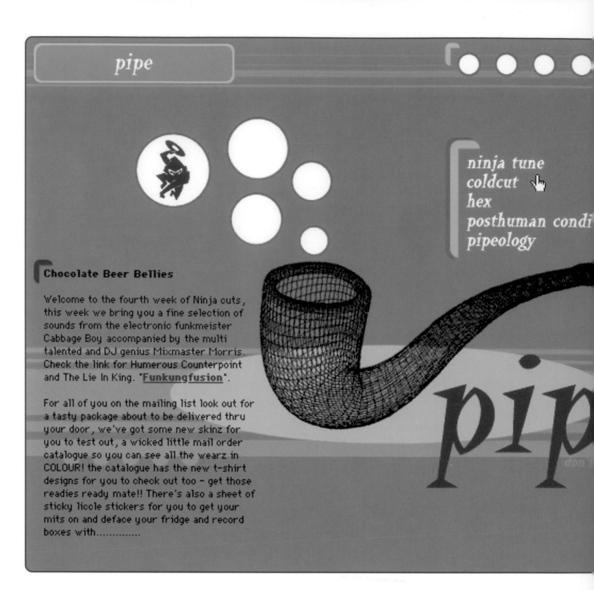

pipe

ninja tune
coldcut
hex
posthuman condi
pipeology

Chocolate Beer Bellies

Welcome to the fourth week of Ninja cuts, this week we bring you a fine selection of sounds from the electronic funkmeister Cabbage Boy accompanied by the multi talented and DJ genius Mixmaster Morris. Check the link for Humerous Counterpoint and The Lie In King. "**Funkungfusion**".

For all of you on the mailing list look out for a tasty package about to be delivered thru your door, we've got some new skinz for you to test out, a wicked little mail order catalogue so you can see all the wearz in COLOUR! the catalogue has the new t-shirt designs for you to check out too – get those readies ready mate!! There's also a sheet of sticky liccle stickers for you to get your mits on and deface your fridge and record boxes with...............

title **pipe**

web address **www.obsolete.com/pipe**

client **Ninja Tune Records**

design companies **Kleber (design & implementation), Openmind (original graphics)**

software **bbedit, director, freehand, gifbuilder, illustrator, photoshop, sound edit**

origin **UK**

type of site **promotion, retail**

work description **a site representing Ninja Tune, Coldcut and other artists, featuring the label catalog, merchandise, clubs, and news**

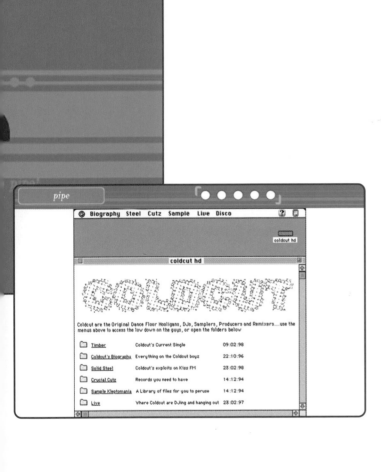

title **Kylie Ultra**™

web address **www.kylie.com**

client **Deconstruction**

design **Chris McGrail**
(design and implementation),
Joe Berger (illustration), Tom Hume (java)

design companies **Kleber, Good Technology**

software **bbedit, freehand, photoshop**

origin **UK**

type of site **promotion**

work description **This site serves as a vehicle for**
the promotion of Kylie's releases as well as being
a fun, intimate, and unconventional interface to
Kylie herself; these values are enforced by Kylie,
who regularly adds photos and contributes a
diary section.

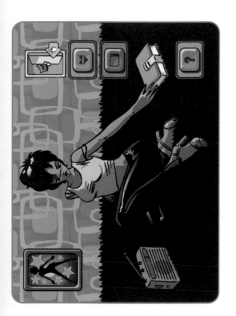

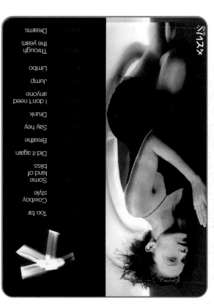

title **Source Records**

web address **www.obsolete.com/source**

client **Source Records**

design **Chris McGrail, Jonas Grossman**

design company **Kleber**

software **bbedit, freehand, photoshop**

number of pages **50**

origin **UK/Germany**

type of site **promotion**

work description **a graphically intense online presence for Source Records, providing a library of sound extracts, biographical information, and a shockwave fridge**

Synchronised Chaos TV is a video project from Jonas Grossmann.

SCTV03 is on-site now, with SCTV01 & SCTV02 coming soon.

Source/Installations

Fridge

General Magic & Pita present
some infotainment for their
forthcoming release on Source,
"Live and Final Fridge."

Planet Jazz

Crazy Babe Tom's debut 10" for
Source re-interpreted with
Shockwave.

Live and Final Fridge

title **Warpnet**

web address **www.warp-net.com**

client **Warp Records**

design **Chris McGrail, Dorian Moore**

design company **Kleber**

original artwork **The Designers Republic**

software **bbedit, director, flash, freehand, jdk, photoshop, sound edit**

origin **UK**

type of site **promotion, retail**

work description **a site expanding upon Warp Records' online presence, providing comprehensive information on their releases and a forum for visitors to communicate with each other and buy records online**

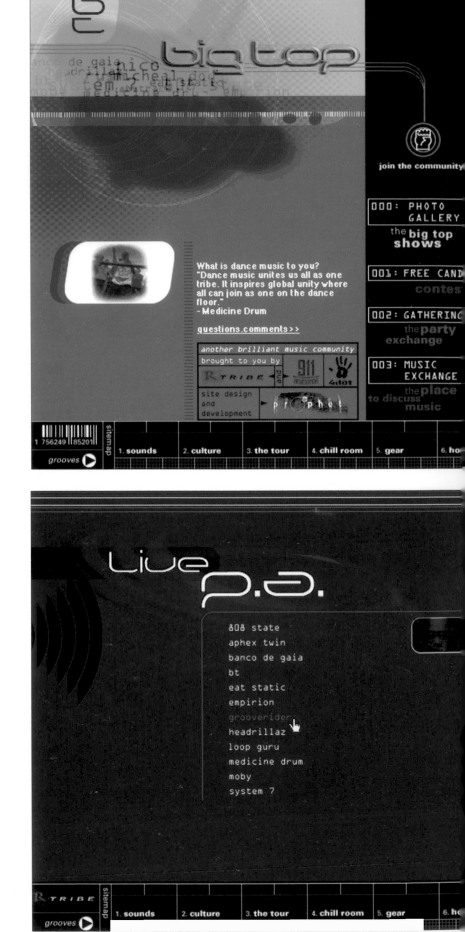

title **Big Top Tour website**

web address **www.bigtoptour.com**

client **911 Entertainment**

design **Josh Feldman, Soy Pak, Rob Brown**

design company **Prophet Communications**

(now frog)

software **bbedit, cold fusion, gifbuilder,**

illustrator, photoshop, strata 3d

number of pages **300+**

origin **USA**

type of site **promotion**

work description **This site promotes the Big Top Tour – a techno and electronica concert festival – and brings techno fans together to build an online community.**

title **Warped World website**

web address **www.warpedworld.com**

client **911 Entertainment**

design **Josh Feldman, Aaron Becker, Soy Pak**

design company **Prophet Communications**

(now frog)

software **bbedit, cold fusion, gifbuilder,**

illustrator, photoshop

number of pages **700+**

origin **USA**

type of site **promotion**

work description **This site promotes the Warped Tour – a skate/punk/ska touring extravaganza – showcasing the bands, skaters, and slide shows involved in the tour, and enabling fans to communicate with each other electronically.**

les simplist men entstanden im August 94 aus
Fusion zwischen den afrikastämmigen Rapper
N'Toum Essia und Bastos Seck und einer Jazz
aus Basel.

title **!WORK**
client **Berufsberatung Baselland (Career Advisory**
Commission of the Basle Region)
design **Martin Grether, Catherine Lutz-Walthard**
design company **HyperStudio AG**
software **after effects, deck II, director,**
illustrator, photoshop, premiere, sound edit,
strata studio pro
origin **Switzerland**
type of CD ROM **education**

work description **This CD-ROM, designed by a**
non-profit-making research and production
institution, informs and motivates young
people deciding upon a career. It outlines
opportunities in selected trades, describes
available resources and services, and provides
useful tips and addresses.

pages 110-13

title **volumeone**

web address **www.volumeone.com**

design **Matt Owens**

design company **volumeone**

software **bbedit, flash2, gifbuilder, illustrator,**
photoshop, raydream designer

origin **USA**

type of site **information, education, promotion**

work description **a self-promotional site for**
volumeone – a visual communications studio
dedicated to the exploration of new narrative
possibilities and interactive solutions through
the medium of the internet

comfortable

purgatory
i know it well

she had the foresight to do just enough
to give her the knowledge to decide to not decide

unfortunately deciding not to decide was
still a judgement that had
its own set of repercussions

made in japan

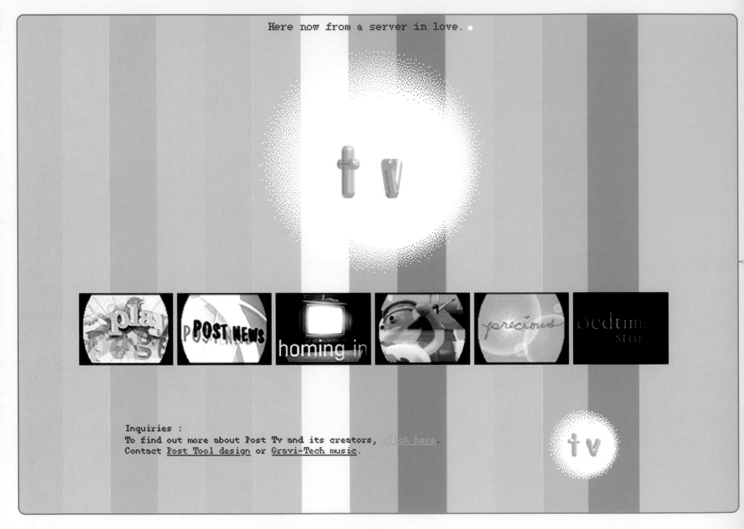

title **Post TV**

web address **www.posttv.com**

design **David Karam, Gigi Biederman, Susan Harris, Stella Lai**

design company **Post Tool Design**

software **after effects, bbedit, debabelizer, director, illustrator, infini-d, photoshop, sound edit**

number of pages **45**

origin **USA**

type of site **promotion, entertainment**

work description **Post TV was developed to experiment with new technologies: it is a mock prediction of the future of internet entertainment, created in collaboration with Tom Bland.**

precious

Everything else can drown
in the unreliable shadow of memory.

There is a paradox,
it seems, for a gallery such as
{**f o u r w a l l s**, in the business
of showing work of intention,
to present images
which have
no known maker or intent.
If art is often trying
to examine
the human condition,
these photographs,
in their unmediated state,
simply are
the human condition.

The **eight** participants have overlapping yet
distinct ways

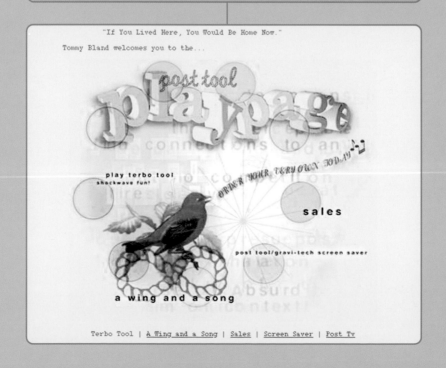

"If You Lived Here, You Would Be Home Now."

Tommy Bland welcomes you to the...

post tool
playpage

play terbo tool
shockwave fun!

ORDER YOUR VERY OWN TODAY

sales

post tool/gravi-tech screen saver

a wing and a song

Terbo Tool | A Wing and a Song | Sales | Screen Saver | Post Tv

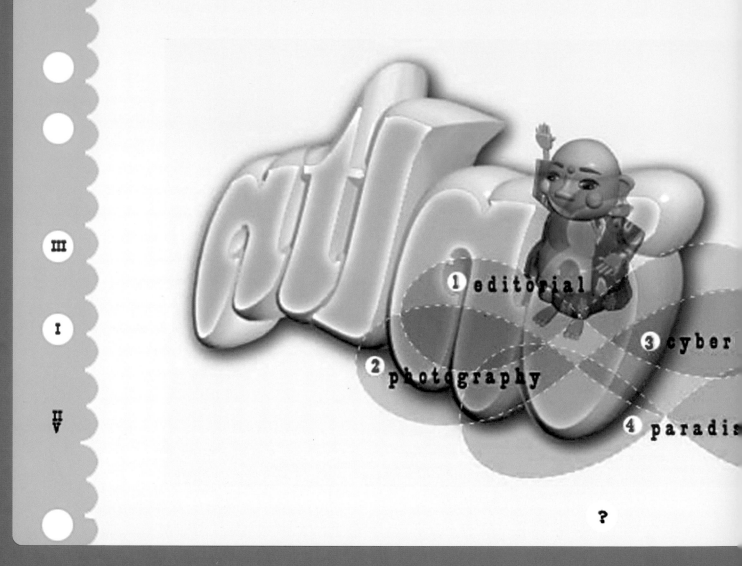

editorial

1

2 photography

3 cyber

4 paradis

?

title **Atlas**

web address **www.atlasmagazine.com**

design **Olivier Laude, Amy Franceschini, Michael Macrone**

design company **Atlas Web Design**

software **bbedit, illustrator, photoshop**

number of pages **2000**

origin **USA**

type of site **education**

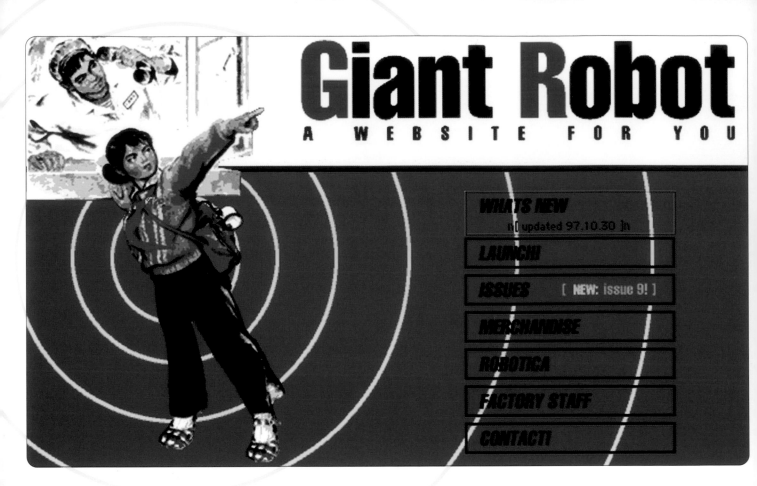

Giant Robot
A WEBSITE FOR YOU

WHATS NEW
n[updated 97.10.30]n

LAUNCH!

ISSUES [NEW: issue 9!]

MERCHANDISE

ROBOTICA

FACTORY STAFF

CONTACT!

[ROBOTICA]

Welcome to **Robotica!** Here you will find a gallery of nasty photojournalism by Martin and Eric. We have attempted to keep the photocopy quality of the images. Why? Cause they rock.

title **Giant Robot**

web address **www.giantrobot.com**

design **David Yu**

software **bbedit, debabelizer, illustrator,**

photoshop

origin **USA**

type of site **information, education, promotion,**

retail

work description **a site promoting the paper edition**

of Giant Robot – an Asian/American magazine

title **SPUMCO**

web address **www.spumco.com**

design **Steve Worth, John Kricfalusi**

(art direction)

design company **Spumco International**

software **flash**

number of pages **100s**

origin **USA**

type of site **entertainment, animation**

work description 'The Goddamn George Liquor
Program,' by the creator of 'The Ren and Stimpy
Show,' is the first cartoon series produced
exclusively for the internet.

SANFRANCISCOMAY 27-29 '98

07 | FUSE98:BEYONDTYPOGRAPHY |

Me[R]gn

Enter FUSE98.com

Enter alternate version

FUSE98.com is an experimental site using DHTML. It is best experienced on a fast machine or connection. Other users may view an alternate (non-DHTML) version.

▲ This site has been realised by MetaDesign.

▼ We welcome your feedback on this site.

NEWS|LOCATION|NAMES|AGENDA|REGISTER|LAB

the new body electric

FUSE98:|BEYONDTYPOGRAPHY|

"There's no development without research. We have to adopt the same strategy with ideas." Jon Wozencroft

Jon Wozencroft will be appearing on Friday 29th of May at 4:30 PM
Check his biography under NAMES/SPEAKERS

NEWS|LOCATION|NAMES|AGENDA|REGISTER|LAB

FUSE98:|BEYONDTYPOGRAPHY|

Rhonda.
Site-specific performances and installations by artists, musicians and architects are a welcome departure from the portfolio parades that are often disguised as design conferences. But why is it called "The New Body Electric"?

Neville
The original body electric is the Chinese Chi, or the energy which relates to Chi and relates to life, and all sorts of internal processes. The New Body Electric came out of an idea that in all of this we're redefining ourselves. We define ourselves through the media that surrounds us. And we define ourselves through our ability to communicate and seek communication. We've lost the sense of being an internal process.

Rhonda.
How does that relate to design?

Neville
It relates to design because design has become one of the ways of manifesting that process, of externalization, of an obsession with style and technology. An obsession with this neurotic obsession to communicate. I can rethink therefore I am. Five or ten years ago, design was definitely a vital area of creative expression. But I think it's lost that. I think it's reverted to becoming a fringe trend.

(Might we be referring to the early 1980s when The Face, which happened to be designed by Mr Brody, was the magazine that through its typographic manipulation, and visual coverage of the prolific music scene, became the defining magazine of the decade?)

Rhonda.

title **FUSE98.com**

web address **www.fuse98.com**

client **FUSE Conferences**

design **Olivier Chételat, Shawn Hazen, Joseph Ternes, Eva Walter, David Peters (production), Rick Lowe (design direction)**

design company **MetaDesign, San Francisco**

software **bhedit, illustrator, photoshop**

number of pages **70**

origin **USA**

type of site **information, promotion**

work description **This site promotes 'Beyond Typography' — an international design event presented in San Francisco by MetaDesign, with Neville Brody and FontShop International. The site gives information about the conference, enables people to preview the location, and register in advance; it also features FUSE98Lab, a test area for digital experiments submitted by designers from around the world. The site was written in DHTML to create a 'one page wonder' providing users with a constant frame of reference into which information is revealed.**

title **IDEO.com**

web address **www.ideo.com**

client **IDEO Product Development**

design **Michael Abbink, Olivier Chételat,**

Kevin Farnham, Patrick Newbery, Joseph Ternes

design company **MetaDesign, San Francisco**

software **bbedit, flash, photoshop**

number of pages **115**

origin **USA**

type of site **promotion**

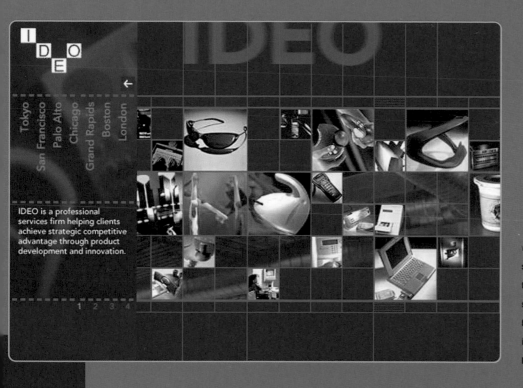

IDEO

Tokyo
San Francisco
Palo Alto
Chicago
Grand Rapids
Boston
London

1 2 3 4

IDEO is a professional services firm helping clients achieve strategic competitive advantage through product development and innovation.

work description **As part of IDEO's overall web strategy, this site represents an interim solution for the company's entry to the web arena, and showcases the products they have produced. IDEO required a technologically sophisticated site: it uses advanced javascript features as well as Macromedia's flash application.**

IDEO

Tokyo
San Francisco
Palo Alto
Chicago
Grand Rapids
Boston
London

IDEO has served clients in more than twenty countries from its seven office locations in North America, Europe and Japan.

1 2 3 4

Matsushita
Fat Billy Iron

Matsushita wanted an instantly recognizable iron that would retain quality, feel, and value, while realizing lower manufacturing costs. IDEO developed the Fat Billy to differentiate it from other irons on the market in terms of visual impact, ease of use, and transportability.

Wert & COMPANY INC

HOME
COMPANY
CANDIDATES
& CLIENTS
COMMUNITY
CONTACT

CLIENTS

CLICK HERE IF YOU WOULD LIKE US
TO CONTACT YOU.

Although our clients vary dramatically in size and purpose, they share with us a high regard for creative integrity and a strong commitment to the future. They appreciate that recruitment is a strategic process, requiring a balance of short-term expediency and long-range goals.

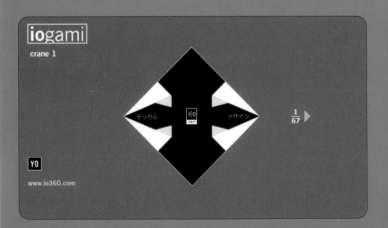

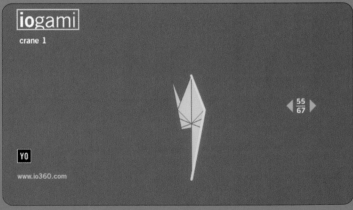

title **iogami website**

web address **www.io360.com**

design **Casey Reas**

design company **i/o 360°**

software **bbedit 4.0, flash 2.0, illustrator 6.0, mksite 2.0**

number of pages **16**

origin **USA**

type of site **promotion, education**

work description **Traditional origami transmits culture and tradition through the transformation of paper squares into three-dimensional forms. The iogami site captures the spirit of this traditional craft and educates through motion. By displaying the interim forms created by the folding paper, iogami eliminates the need for explanatory text and allows users to control the pace of the folding process.**

title **Wert & Company website**

web address **www.wertco.com**

client **Wert & Company**

design **Dindo Magallanes**, **Casey Reas**

design company **i/o 360°**

text **Julie Moline, Malcolm Abrams**

software **bbedit 4.0, debabelizer 1.5.52, flash 2.0, illustrator 7.0, inspiration 5, mksite 2.0**

number of pages **38**

origin **USA**

type of site **promotion, information**

work description **This site promotes an international recruitment agency specializing in the creative community; potential clients can request further information and job candidates can submit information to the company's database. The graphic language of the site (large areas of flat color, circles, ampersands, and a visible grid) evolved out of the company's identity. i/o 360° developed this visual language through a series of animated sequences that form a decodable analogy to the company's business.**

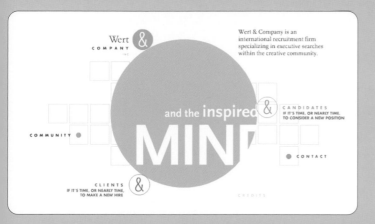

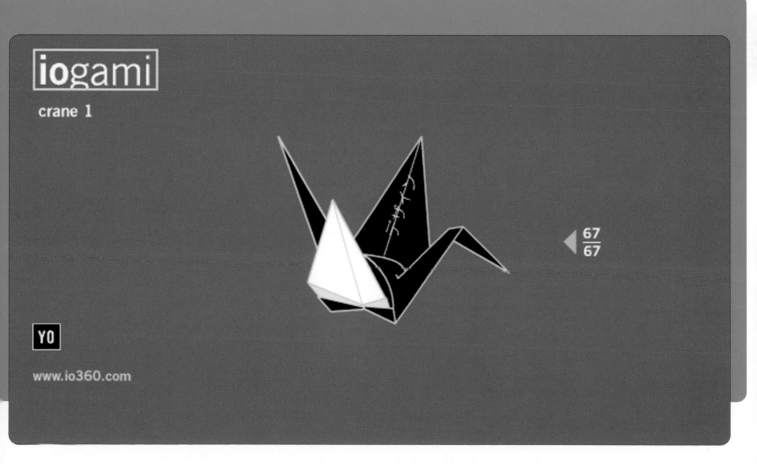

internet graphics splinter multimedia contact

100 good reasons

Splinter offers a fresh approach to design for printed applications, interactive multimedia and the internet. Our philosophy and approach to any brief encompasses technological innovation whilst never losing sight of the fact that design is all important. We are committed to producing creative, commercially effective design solutions working hand-in hand with our clients. Our design thinking is based on a strong understanding of the client and their needs, achieved through continual communication and feedback.

This site is Shockwave intensive - get the plug-in. Netscape 3/ Internet Explorer4 recommended.

internet graphics splinter multimedia contact

Graphics

Splinters approach to the art of graphic communication is based on a solid understanding of our clients and their needs. Through the combination of skills in a wide range of disciplines we aim to produce fresh, creative and appropriate solutions to any design problem. Our work to date includes graphics for corporate identity, signage, packaging, promotion, book jackets and commisioned typeface designs.

NEVER MIND THE BANDWIDTH...
FEEL THE QUALITY

internet graphics splint multimedia contact

Please contact us if you have any queries regarding costs, timescales and how Splinter can help you.

0151 7099077

title **Splinternet**

web address **www.splinter.co.uk**

design **Chris Beer, Paul Musgrave, Sam Wiehl**

design company **Splinter**

software **bbedit, gifbuilder, illustrator, photoshop**

number of pages **15**

origin **UK**

type of site **promotion**

work description **This self-promotional site for Splinter design company showcases their print and new media work; all the fonts used in Splinternet are designed by Beaufonts.**

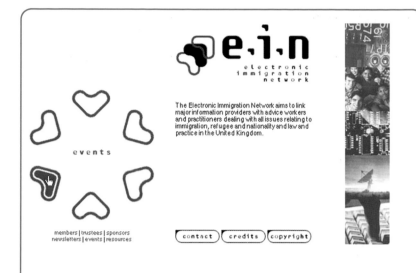

The Electronic Immigration Network aims to link major information providers with advice workers and practitioners dealing with all issues relating to immigration, refugee and nationality and law and practice in the United Kingdom.

events

members | trustees | sponsors
newsletters | events | resources

contact credits copyright

members

trustees

sponsors

newsletters

events

resources

alphabetical country category

A|B|C|D|E|F|G|H|I|J|K|L|M|N|O|P|Q|R|S|T|U|V|W|X|Y|Z

A

Acts of Parliament 1997

Amnesty Library

Amnesty International (AI)

Amnesty Search Engine

Amnesty Campaign Reports

Amnesty News Releases

European Crosspoint Anti-Racism
Links to organisations worldwide working in the field of human rights, anti-racism, refugees, anti-fascism etc. (Magenta Foundation, Amsterdam, The Netherlands)

Asylum and Immigration Act 1996: Guidance for Employers

Asylum and Immigration Act 1996
This document can be found amongst the Acts of Parliament 1996 published by HMSO.

le E.I.N website

eb address www.ein.org.uk

ent Electronic Immigration Network

sign Chris Beer

sign company Splinter

ftware bbedit, photoshop

mber of pages 14

igin UK

pe of site information

ork description This site provides information

a issues relating to immigration in the UK.

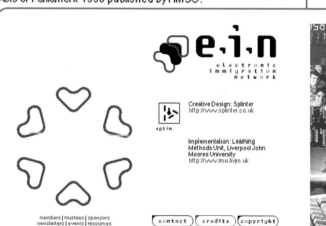

Creative Design: Splinter
http://www.splinter.co.uk

Implementation: Learning Methods Unit, Liverpool John Moores University
http://www.lmu.livjm.uk

members | trustees | sponsors
newsletters | events | resources

contact credits copyright

title **BBDO website**

web address **www.bbdo.com**

client **BBDO/West**

design **ReVerb, Los Angeles, Jennifer Boyd**

(creative director/BBDO)

design companies **ReVerb, Los Angeles, BBDO**

software **illustrator, photoshop**

number of pages **40**

origin **USA**

type of site **promotion**

work description **ReVerb's brief was to create a 'corporate hip' image for the launch of BBDO worldwide's website, to establish the advertising giant as a leading-edge new media presence; cursor-responsive shockwave elements enhance unique splash screens.**

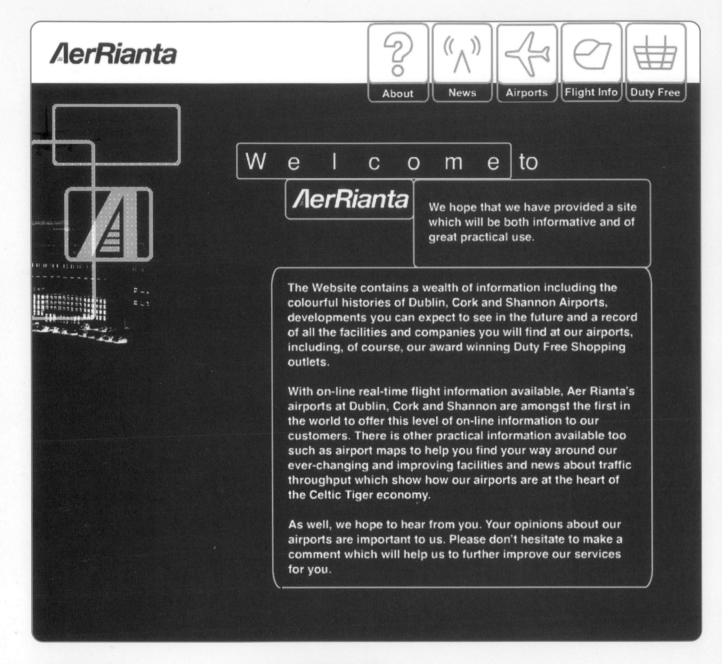

AerRianta

About News Airports Flight Info Duty Free

W e l c o m e to

AerRianta

We hope that we have provided a site which will be both informative and of great practical use.

The Website contains a wealth of information including the colourful histories of Dublin, Cork and Shannon Airports, developments you can expect to see in the future and a record of all the facilities and companies you will find at our airports, including, of course, our award winning Duty Free Shopping outlets.

With on-line real-time flight information available, Aer Rianta's airports at Dublin, Cork and Shannon are amongst the first in the world to offer this level of on-line information to our customers. There is other practical information available too such as airport maps to help you find your way around our ever-changing and improving facilities and news about traffic throughput which show how our airports are at the heart of the Celtic Tiger economy.

As well, we hope to hear from you. Your opinions about our airports are important to us. Please don't hesitate to make a comment which will help us to further improve our services for you.

title **Aer Rianta website**

web address **www.aer-rianta.com**

client **Aer Rianta**

design company **Webfactory Ltd.**

software **debabelizer, dreamweaver, flash, freehand, gifbuilder, illustrator, photoshop, sound edit**

number of pages **1135**

origin **Ireland**

type of site **information, promotion**

work description **The Aer Rianta site provides a real-time searchable database of flight arrival and departure information for Dublin, Cork, and Shannon airports; it includes a flash animation introduction, an a-z of facilities, a map of each airport, and duty free information.**

title **Eircell website**

web address **www.eircell.ie**

client **Eircell**

design company **Webfactory Ltd.**

software **debabelizer, dreamweaver, freehand, gifbuilder, illustrator, photoshop, sound edit**

number of pages **727**

origin **Ireland**

type of site **information, promotion**

work description **This online guide to Eircell's mobile phone service in Ireland complements their offline branding and gives users information on all the company's services and sponsorship; an online racing game is a highlight, offering a free trip to the Monza Grand Prix as its top prize.**

title **Pathogen; The Visitor@Mediadome**

client **Centropolis, C/NET, Intel**

design **Dave Bravenec, Ken Olling (art direction)**

design company **<tag> media**

software **flash, illustrator, photoshop**

number of pages **60**

origin **USA**

type of site **entertainment**

work description **This project is a linear narrative, separately written from 13 TV episodes of 'The Visitor' appearing on C/NET's Mediadome. The piece took the form of an interactive flash animation where the viewer could travel inside the visitor's subconscious and be given choices that changed the story's outcome positively or negatively.**

title **MEDIALAB 3D**

web address **www.medialab3d.com**

client **MEDIALAB**

design **Ken Olling**

design company **<tag> media**

programming **Steven Anspach**

software **freehand 5.5, gifmation 2, photoshop 4**

number of pages **20**

origin **USA**

type of site **information**

work description **This website serves as an introduction to MEDIALAB production company; it is platform agnostic: Mac, PC and Unic look identical, using absolute positioning, javascript, dynamic page generation, and cgi.**

title **The Visitor**

client **Centropolis, Intel**

design **David Vegezzi, Dave Bravenec, Leri Greer, Ward Bones, Erik Loyer, Ken Olling (art direction)**

design company **<tag> media**

software **flash, freehand, illustrator, photoshop**

number of pages **160**

origin **USA**

type of site **entertainment**

work description '**The Visitor.com' is an exploration of online storytelling and parallel media entertainment. The site is a multi-layered, truly hypertextual world created behind, in, and around that of the Fox television series 'The Visitor,' utilizing flash animation, streaming media, DHTML, and javascript to push the envelope of the interactive web experience.**

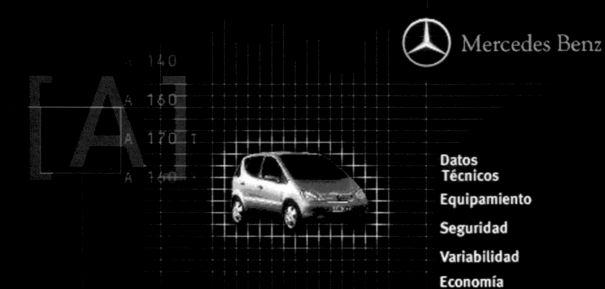

Mercedes Benz

[A]

140
A 160
A 170 T
A 140

[Diálogo Clase A]

Datos
Técnicos

Equipamiento

Seguridad

Variabilidad

Economía

Ecología

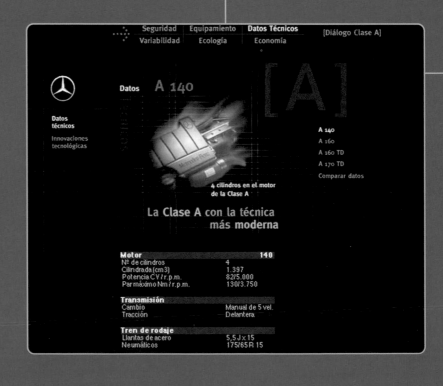

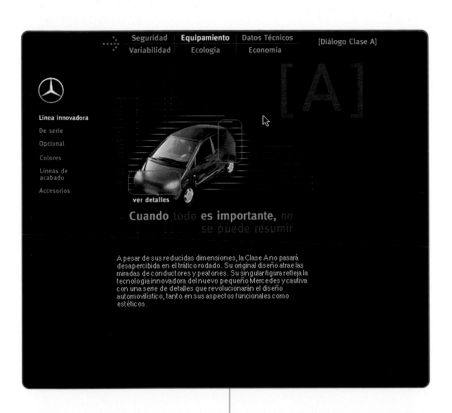

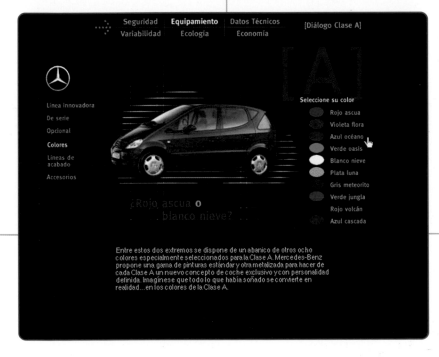

title **Clase A website**

web address **www.clase-a.com**

client **Mercedes Benz España S.A**

design **Andreas Grönqvist, Juan Mantilla,
Johan Thorngren, Mike Blake**

design company **Icon Medialab S.A.**

software **activex control pad, freehand 7,
gif animator, home site 2.5, photoshop 4.0**

number of pages **35**

origin **Spain**

type of site **promotion**

work description **This site promotes the Class-A
Mercedes automobile; the user is pulled through
the site by using active elements functioning
across browsers.**

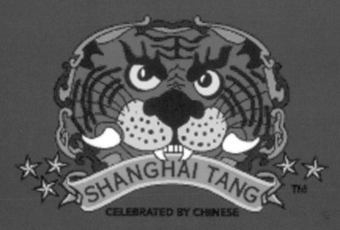

title **Shanghaitang**

web address **www.shanghaitang.com**

client **Tang Department Stores**

design **David Mok (creative direction),**
Sean Clarke (project management),
Frederic Litchenstein (art direction),
Sean Wood (art direction)

design company **Lemon**

programming **Mitch Leung**

software **after effects, director, freehand,**
photoshop

number of pages **25**

origin **Hong Kong, China**

type of site **promotion, retail**

work description **This site promotes Shanghaitang**
– a clothing emporium selling Chinese-inspired
clothing and houseware with a modern twist.
The website brings the Shanghaitang 'essence'
online: humor, bright colors, and spirit.

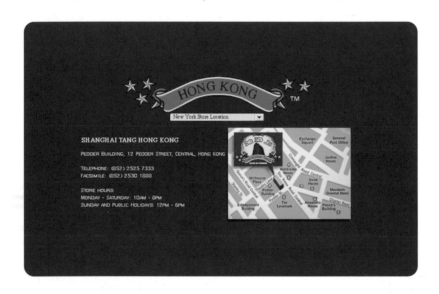

title **XLarge website**

web address **www.xlarge.com**

client **XLarge MFG LLC**

design **Michael Worthington, Tracy Hopcus**

design company **Michael Worthington Design**

software **illustrator, photoshop, web color,**

web map, world-wide-web weaver

number of pages **120**

origin **USA**

type of site **retail**

work description **This site aims to display XLarge clothes in a creative, fun way; the interface is designed to be intuitive, and memories of color and shape are used as navigation aids.**

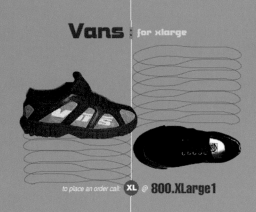

title **The 'Provinzial' Art Collection**

client **Provinzial Versicherung, Düsseldorf**

design **Heike Albig, Bruno Bakalovic´, Silke Holtz**

design company **K/PLEX**

software **director, quicktime**

origin **Germany**

type of **CD-ROM information, promotion**

work description **This multimedia guide to the art collection of an insurance company is projected on to a screen in the company's foyer. The design team avoided a linear form of documentation by superimposing images; the use of the Wittgenstein quote 'the concept of seeing makes a confusing impression because we do not allow ourselves to be confused enough by seeing as a whole' is the basic idea behind the design.**

title **STS – 'The Regulation Game'**

client **Severn Trent Systems**

design **Ainsley Bowen**

design company **Magmed:**

New Media Communications

software **director 6.0, illustrator 7.0,**

photoshop 4.0

origin **UK**

type of CD ROM **promotion, information**

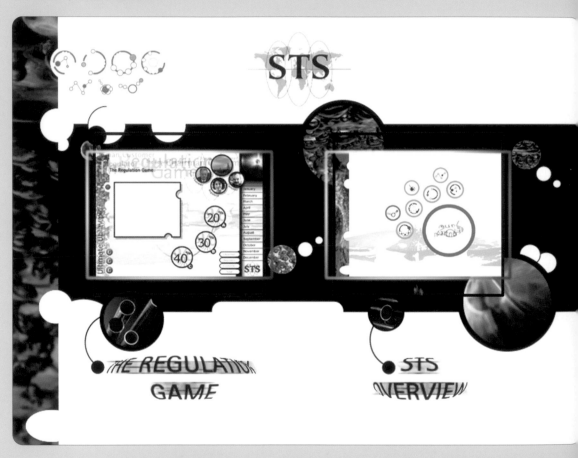

work description **an award-winning touch-screen interactive presentation, offering I.T. solutions to newly emerging privatized utility companies, presented at the industry's annual exhibition**

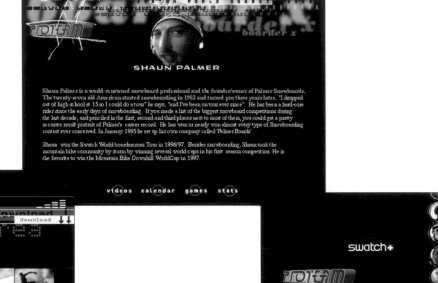

title **swatch PROTEAM**

web address **www.swatch.com/proteam**

client **swatch**

design **Hien Im, Roberto Costa (art direction),**
Sandro de Pestel (lab management)

design company **Swatch Communication Lab**
(New York)

programming **Robert Corilli, ID-Gruppe (Germany)**

software **illustrator, photoshop**

origin **USA/Germany**

type of site **promotion**

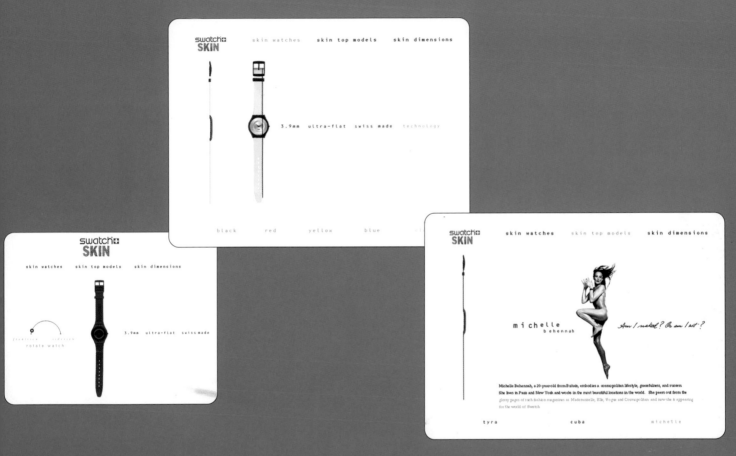

title **swatch SKIN**

web address **www.swatch.com/skin**

client **swatch**

design **Hien Im, Roberto Costa (art direction),**

Sandro de Pestel (lab management)

design company **Swatch Communication Lab**

(New York)

photography **Michel Comte**

programming **ID-Gruppe (Germany)**

software **illustrator, photoshop**

origin **USA/Germany**

type of site **promotion**

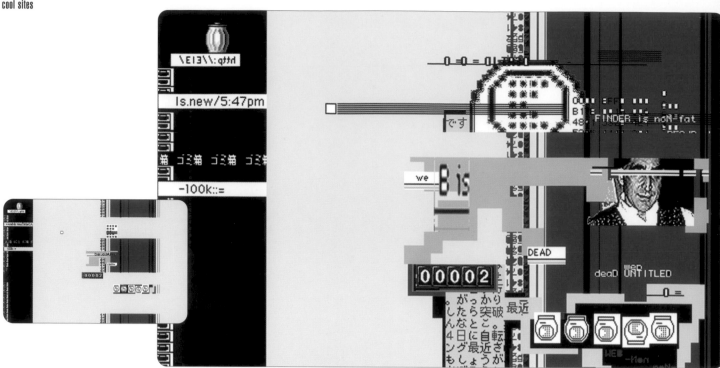

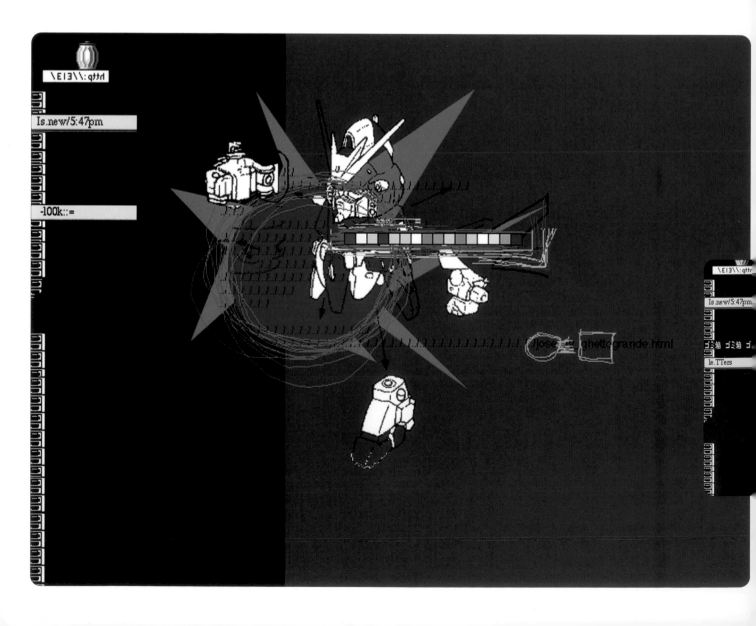

pages 152-55

title **E13 website**

web address **www.e13.com**

design **Eric Rosevear**

design company **E13 projects**

software **after effects 3.1, bbedit 4.5, cubase 3.52, debabelizer 1.6, director 6.0, dreamweaver 1.0, gifbuilder 0.5, netscape communicator 4.05, photoshop 4.0, premiere 4.2.1, quicktime 3.0, sound edit 16, transparency 1.0**

origin **USA**

type of site **experimental**

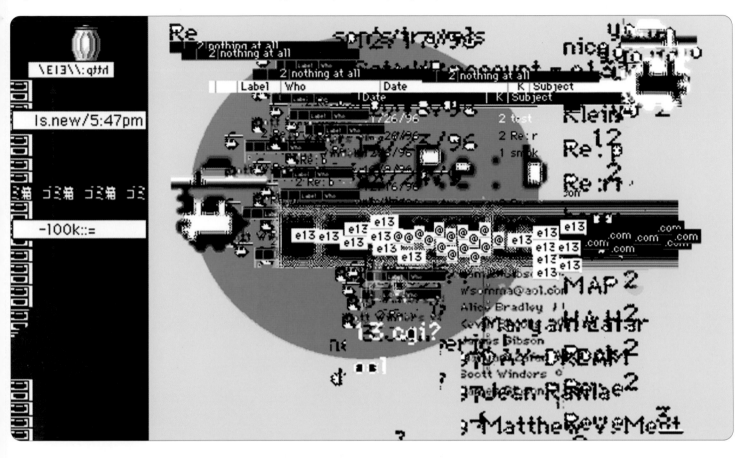

who.it

be

SUmo butter
mASTER,

in

BIG
TOKYO

BUTTER

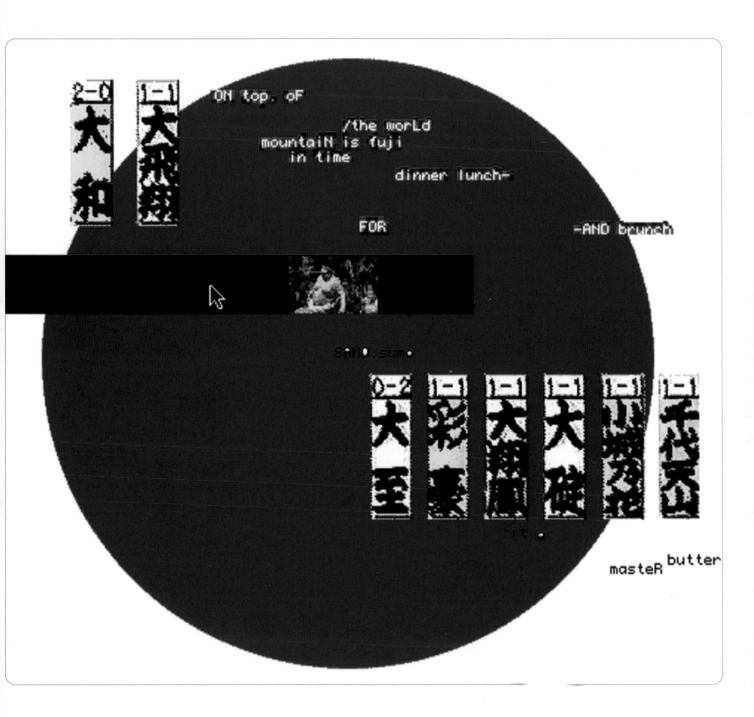

number of pages **100+**

origin **Norway**

title **Amoeba website**

type of site **information**

web address **www.evolutionzone.com**

design **Marius Watz**

design company **Amoeba**

software **bbedit, custom 2d + 3d, emacs, illustrator, photoshop, pov-ray**

work description **an online 'toolshed' of ideas for evolution in culture, design, and mindware**

form undermines function
and causes movement towards change

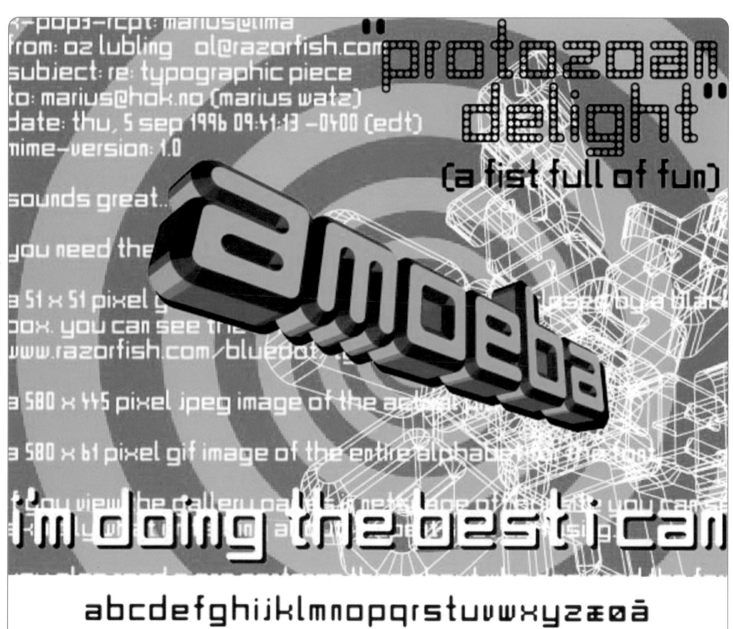

x-pop3-rcpt: marius@ultima
from: oz lubling ol@razorfish.com
subject: re: typographic piece
to: marius@hok.no (marius watz)
date: thu, 5 sep 1996 09:41:13 -0400 (edt)
mime-version: 1.0

"protozoan delight"
(a fist full of fun)

amoeba

sounds great...

you need the

a 51 x 51 pixel

box. you can see the

www.razorfish.com/bluedot

a 580 x 445 pixel jpeg image of the actual

a 580 x 61 pixel gif image of the entire alphabet

i'm doing the best i can

abcdefghijklmnopqrstuvwxyzæøå
abcdefghijklmnopqrstuvwxyzæøå

title **Funnel**

web address **www.funnel.com**

design/illustration **Erik Adigard, Patricia McShane**

design company **M.A.D.**

programming **Erik Adigard, Patricia McShane, Dave Granvold**

text **Laurence Arcadias, Lindsay Gravette, Ken Coupland**

software **director, photoshop, raydream designer, shockwave afterburner**

number of pages **8**

origin **USA**

type of site **experimental, information**

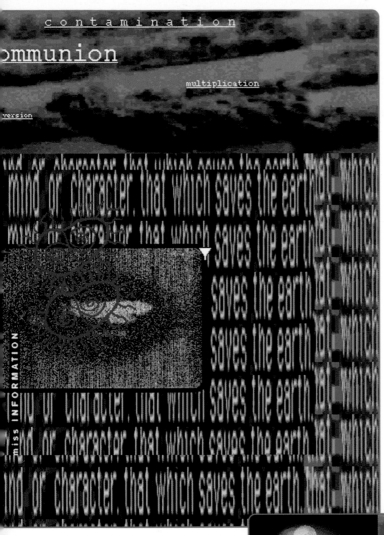

work description **This site was conceived as a
'virtual sandbox' for experimental art and graphic
design; the project is a collaboration between
writers, programmers, designers, and artists.
The VI'R'US edition of Funnel's digital display
tackles the theme of contagion in the modern
world; the site counts down to the year 2000 in
days, minutes, and seconds. M.A.D's shockwave
site is one of the first art websites to be included
in the collection of SFMOMA.**

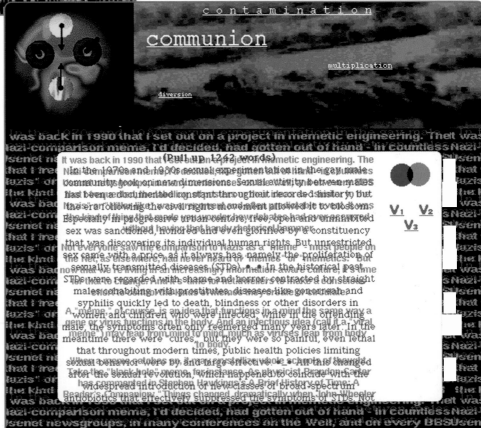

Wed, 22 Apr 1998 14:43:12 GMT

usrts2p249.port.net

usrts2p249.port.net

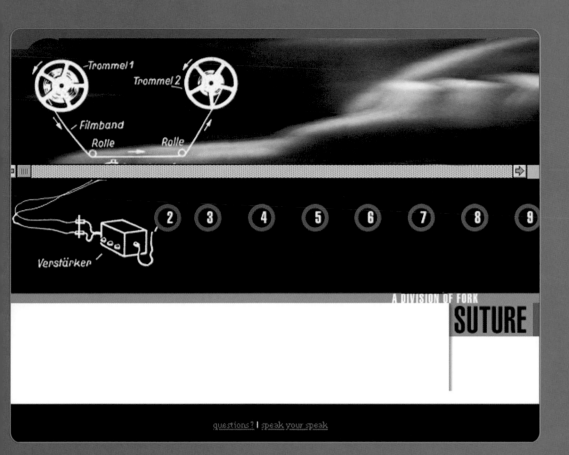

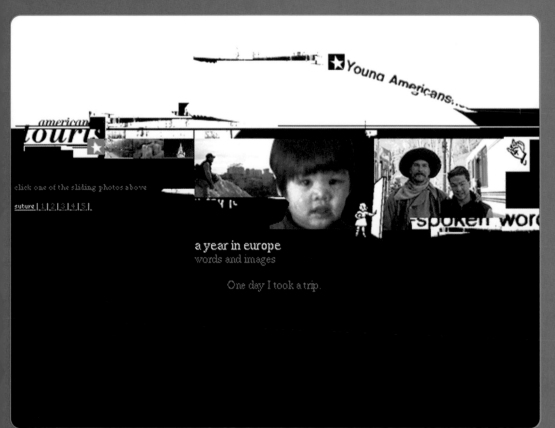

title **suture / open wounds**

web address **www.suture.com**

design **Jeremy Abbett**

design company **FORK Unstable Media**

software **bbedit, director, freehand, photoshop**

number of pages **46+**

origin **Germany**

type of site **information**

work description **Suture is a digital sketchbook communicating a person's insights about living an accelerated lifestyle in an antiquated country.**

HOOSKER DONT HoOSkerDoO

Jawbox Jawbox Chanky
Jawbreaker KRAFTWERK
Lambrettista Luncheonette
Laundrette
Liquorstore Mantisboy
Mister Mingler Ritzy
Mingler
Frisky Mingler Tipsy
Mingler Nipsy

Orbital Murkshine
Moonshine Orbus
Parkway Hotel
Parkway Motel
PARKWAY
RESORT-O-TEL
Space Toaster SHAKOPEE
Ribjoint
TABITHA Thymesans
Woodrow

check this out...
Ammonia Badoni Chauncy Deluxxe Mac or Pc
Assowipe Mister Frisky ChauncyFatty Luncheonette
Bawdy Couchlover Uncle Stinky
Bawdy Bold chankstore HoOSkerDoO
Bawdy Italic DENTALPAK Jawbox
Bonehead the complete works of Jawbox Chanky
Brainhead MISTER CHANK DIESEL KRAFTWERK
Buckethead OVER 50 FONTS! Lambrettista
Bawdy Bold Italic Cosmic Eatpoo Skinny Laundrette
CrustiEr DutchTreat Eatpoo Chubby Laundrette
CrustiEst EatpooTall FUCKER HOOSKER DONT Tabitha
Crustiwacky Mr. Lincoln Parkway Hotel PARKWAY
Orbital Parkway Hotel RESORT-O-TEL
OrbusMulti Ribjoint RESORT-O-TEL Space Toaster
Thymesans Woodrow
SIGNED & NUMBERED. LIMITED EDITION! ONLY $299

title Chank Store website

web address www.chank.com

design Mr Chank Diesel & Friends

design company The Chank Company

software gifbuilder, illustrator, photoshop,
simpletext

number of pages 100+

origin USA

type of site promotion

work description an online font library

Index of /

Name

Parent Directory

readme.html

interact/

internal/

junk/

london/

pain/

pleasur/

routeless/

sic/

skint/

<..++creativity++..>

<..life+

title **Irational.org**

web address **www.irational.org**

design **Heath Bunting, Rachel Baker,**

Carey Young, Daniel Andujar

(of the Irational.org collective)

software **agnet tools, bbedit, debabelizer,**

email effects, etherpeek, eudora pro, fetch,

figlet, freehand, hacker's helper, pgp rsa,

photoshop, pict2ascii, telnet

origin **global**

type of site **information**

work description **political intervention**

<..sup(press)ed.=/=..>

<..(pre)(sent)..>

title **Klebeband**

web address **www.kleber.net/klebeband**

client **The Remedi Project**

design **Chris McGrail, Dorian Moore**

design company **Kleber**

software **bbedit, director, flash, freehand,**
infini-d, perl, photoshop, sound edit

origin **UK**

type of site **art installation**

THIS PARTICULAR INDULGENCE HAS BEEN CREATED
BY KLEBER DESIGN LTD AS THEIR CONTRIBUTION TO
THE REMEDI PROJECT.

RUB ➡

1 2 3 4 5 6 7 8 9 ENTER

work description **Kleber's contribution to**
'The Remedi Project,' an installation involving
12–15 artists, curated by Josh Ulm
(www.theremediproject.com)

matthias brucklacher illustration
bühne karton tiny art
eyesaw fontz typography
frank göldner photography
thirtydegreeshirt t-shirts
dirk uhlenbrock illustration

signalgrau.com

THE TAKEAWAY TYPE FOUNDRY

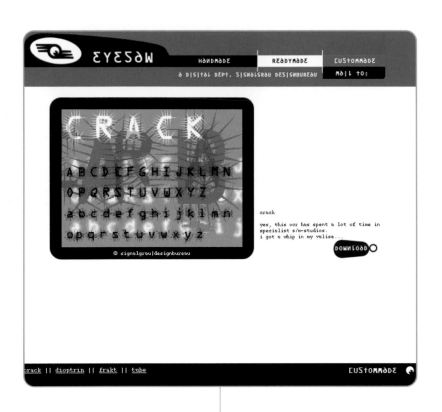

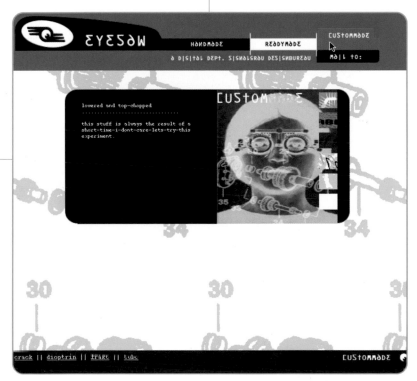

pages 170-73

number of pages **25**

origin **Germany**

type of site **promotion**

title **Eyesaw Fontz**

web address **www.signalgrau.com/eyesaw**

design **Dirk Uhlenbrock**

design company **Signalgrau Designbureau**

software **gifbuilder, golive, illustrator, photoshop, world-wide-web weaver**

work description **a self-promotional site to showcase work and a playground in which to test new ideas**

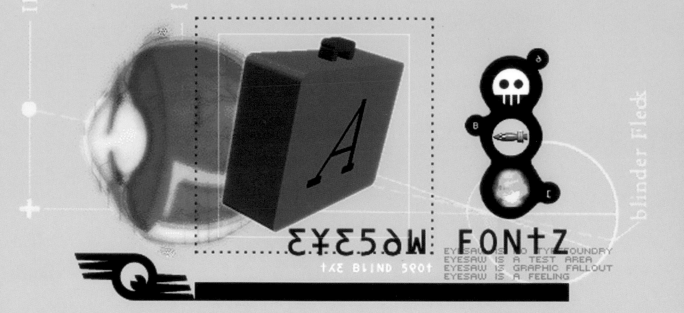

EYESAW FONTZ

THE BLIND SPOT

EYESAW IS NO TYPE FOUNDRY
EYESAW IS A TEST AREA
EYESAW IS GRAPHIC FALLOUT
EYESAW IS A FEELING

blinder Fleck

© signalgrau |designbureau

TAKE ME TO
THE MOON

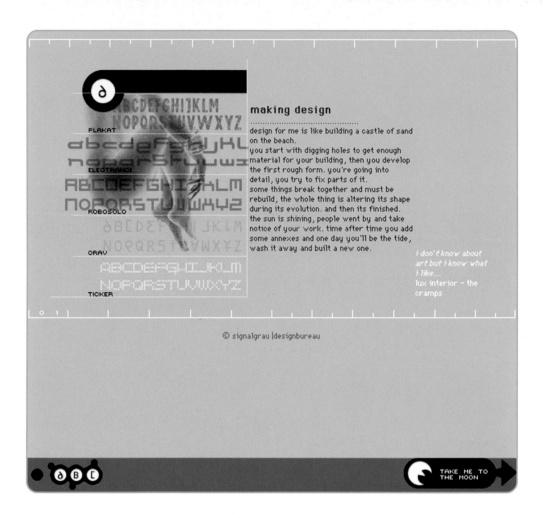

making design

design for me is like building a castle of sand
on the beach.
you start with digging holes to get enough
material for your building, then you develop
the first rough form. you're going into
detail, you try to fix parts of it.
some things break together and must be
rebuild, the whole thing is altering its shape
during its evolution. and then its finished.
the sun is shining, people went by and take
notice of your work. time after time you add
some annexes and one day you'll be the tide,
wash it away and built a new one.

*i don't know about
art but i know what
i like...
lux interior - the
cramps*

PLAKAT

ELEOTRANCE

ROBOSOLO

ORAV

TICKER

© signalgrau |designbureau

TAKE ME TO
THE MOON

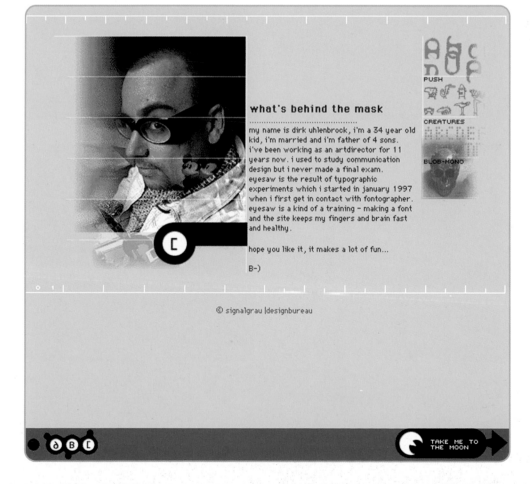

what's behind the mask

my name is dirk uhlenbrock, i'm a 34 year old
kid, i'm married and i'm father of 4 sons.
i've been working as an artdirector for 11
years now. i used to study communication
design but i never made a final exam.
eyesaw is the result of typographic
experiments which i started in january 1997
when i first get in contact with fontographer.
eyesaw is a kind of a training - making a font
and the site keeps my fingers and brain fast
and healthy.

hope you like it, it makes a lot of fun...

B-)

PUSH

CREATURES

BLOB-MONO

© signalgrau |designbureau

TAKE ME TO
THE MOON

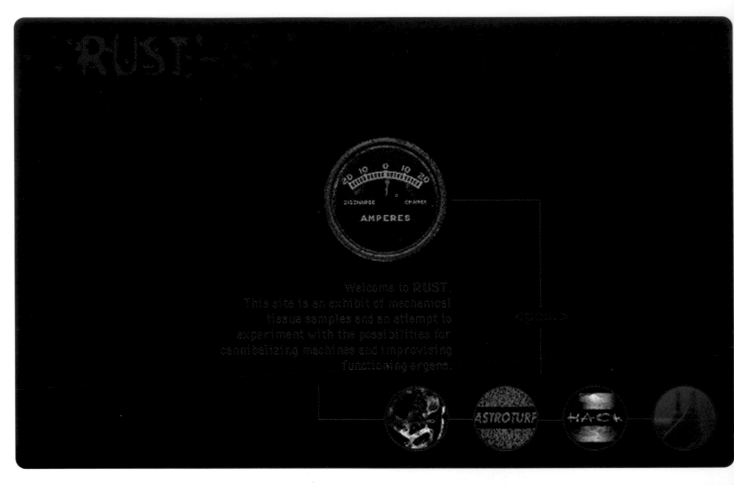

title **rust**

web address **artcon.rutgers.edu/artists/RAVIsites/DEFAULT.HTML**

design **Ravi Rajakumar**

software **debabelizer, photoshop, simpletext**

number of pages **15**

origin **USA**

type of site **art**

title **Experimental Quicktime Loops of**

KingDumb (a typeface)

web address **www.futurefarmers.com**

design **David Harlan**

design company **PopGlory**

software **after effects, illustrator,**

movieplayer, strata studio pro

origin **USA**

type of site **experimental**

title **Surface Type website**

web address **www.surface-type.com**

design company **Surface Type**

software **illustrator, photoshop,
bell gothic typeface family,
clarendon typeface family,
news gothic typeface family**

number of pages **25**

origin **USA**

type of site **promotion**

work description **This site was originally
created for the sole purpose of
displaying and distributing the
company's typefaces, but has since
taken on a minor role in helping to
educate the public about typography
through the company's various
resources and the 'type.edu' section.**

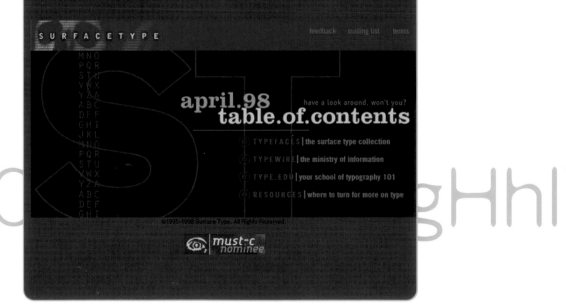

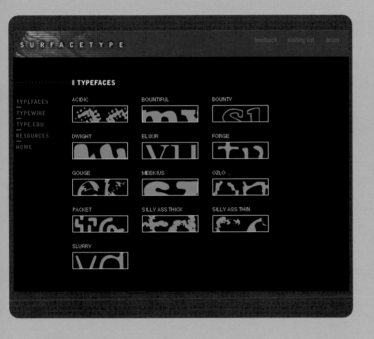

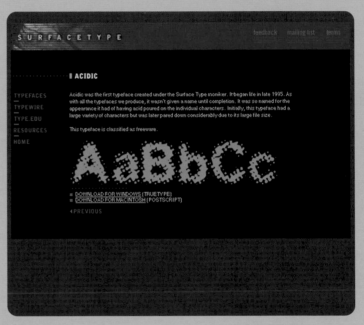

KlMmNnOoPpQqRrSs

title **fontBoy screen saver**

client **fontBoy**

design **Bob Aufuldish**

design company **Aufuldish & Warinner**

programming **David Karam, Dave Granvold**

software **cinemac, director, illustrator, photoshop**

origin **USA**

type of CD ROM **information, promotion**

work description **The fontBoy screen saver uses quotes from Mark Bartlett's essay, 'Beyond the Margins of the Page,' juxtaposed with a soundtrack of snoring. The screen saver randomly connects nine quotes with seven typefaces, and randomly places the quotes on screen. They flash too quickly to read at first glance but, over time, as the same quotes appear again and again, they begin to acquire a kind of sense.**

page 181

title **fontBoy website**

web address **www.well.com/~bobauf/fontboy.html**

client **fontBoy**

design **Bob Aufuldish**

design company **Aufuldish & Warinner**

programming **Bob Aufuldish**

software **illustrator, photoshop**

number of pages **50**

origin **USA**

type of site **information, promotion, retail**

work description **fontBoy wanted a simple, low-maintenance internet presence to avoid the costs and complexities associated with printing and distributing paper-based catalogs. The fontBoy website allows visitors to view the font library in both character and text settings. Selections from Mark Bartlett's essay, 'Beyond the Margins of the Page,' are used throughout the site to put the fonts in their cultural/ theoretical context.**

font Boy

CATALOG

baufy

b a u f y : five font family: $95 = designed by Bob Aufuldish, 1994
{normal} {medium} {bold} {bulky} {chunky} {text sample} {special characters}

roar Shock = 1 2 0 dingbats: two font family: $75 = designed by Bob Aufuldish, 1995
{roarShock 1} {roarShock 2}

VISCOSITY

v i s c o s i t y : three font family: $75 = designed by Kathy Warinner and Bob Aufuldish, 1996
{regular} {inline} {interior} {text sample} {special characters} {swell feature}

Whiplash

w h i p l a s h : three font family: $75 = designed by Bob Aufuldish, 1994
{regular} {monospaced} {lineola} {text sample} {special characters}

{fontBoy home} {order} {email}

font Boy

Imagine a fisherman standing on the shore and casting a line into the ocean. Imagine the immensity of the Pacific and the inconsequential frame of a human being. What an astonishing act; what an absurd image. To expect to catch something under these conditions is almost pathological. The odds of success are apparently miniscule. The pursuit of meaning is an even more astonishing act as we cast into a vastly greater ocean. It requires a type of faith, because even when communication is apparently successful, it can never be guaranteed to be so.

MARK BARTLETT

font Boy

NEW RELEASE

viscosity: regular, inline, interior

EVEN WHEN COMMUNI CATION IS APPARENTLY SUCCESSFUL, IT CAN NEVER BE GUARANTEED TO BE SO

—mark bartlett

v i s c o s i t y : regular, inline, interior = designed by Kathy Warinner and Bob Aufuldish, 1996
three font family: $75

TYPOGRAPHIC.COM **SHADOW EDITION**

number of pages **21**

origin **USA**

type of site **promotion**

design **Jimmy Chen**

design company **typographic.com**

software **bbedit, dimensions, fireworks,**

illustrator, photoshop

pages 182-85

title **typographic.com**

web address **www.typographic.com**

typographic

ABOUT

typographic.com uses this digital genre as a space for experimentation.

...typography...

As computers continue to play a major role in shaping the future of digital typography, this medium will provide endless design solutions.

typographic.com is the fusion of *imagination and technology*

READ WHAT?

typographic.com uses this digital genre as a space for experimentation. It offers an alternative pathway through technology and fresh avenues and ideas for designers.

As computers continue to play a major role in shaping the future of digital typography, this medium will provide endless design solutions.

typographic.com is the fusion of imagination and technology

work description **a site for a digital design studio, specializing in experimental explorations of typography and imagery**

TIMES
ROMAN

US toll-free 888.T26.FONT, tel 773.862.1201,
or fax 773.862.1214

e-mail t26font@aol.com

[T-26] Digital Type Foundry

1110 North Milwaukee Avenue

Chicago, Illinois 60622.4017 USA Planet Earth

title **[T26] Type Foundry**

web address **www.t26font.com**

client **[T26]**

design **Jim Marius, Carlos Segura**

design company **Segura Inc.**

software **bbedit, director, filemaker pro, flash**

number of pages **600**

origin **USA**

type of site **promotion**

work description **This site was designed to showcase and sell [T26] typefaces, as well as create a [T26] environment where other experiments and products could be viewed.**

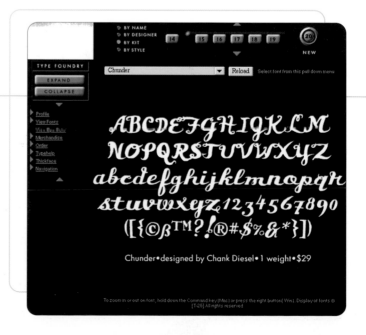

title **Bäehni's Flying Page**

web address **www.access.ch/private-users/baehni**

design **Michael Bäehni**

design company **approx media**

software **bbedit, homepage, photoshop**

number of pages **11**

origin **Switzerland**

type of site **promotion**

work description **a self-promotional site for**

Michael Bäehni's multimedia design work

Öfter mal was neues. Den Frühlingsputz habe ich jetzt auf meiner Page gemacht. Die Wohnung hätte es auch nötig... Freiwillige bitte melden per Mail oder Telefon!

Jetzt wo es draussen überall so bunt wird. Beschränke ich mich farblich aufs Existentielle.

Ich wünsche Dir Spass beim Surfen! Anregungen und Kommentare erwünscht. Positive ins Guestbook, negative per eMail. (hi, hi)

approx. media heisst meine virtuelle Firma, die Multimedia-Produkte entwickelt. Den Multimedia mausert sich je länger je mehr zu meinem zweiten Standbein. Ich beteiligte mich bei verschiedenen CD ROM Produktionen. Schau mal bei der BD ROM rein. (Macromedia Director)

Wie Du siehst gestalte ich auch Internet Auftritte. Als neustes Beispiel. Die Homepage der MALUCO Sport & Ferien AG. (http://www.maluco.ch)

ˈbɔːdɪŋ-
Vocabulary
veʊˈkæbjʊleri

Air: Sprung

Backside: bei dem der Rücken zum Schwungmittelpunkt weist. Fersenkante wird belastet.

Bail: Sturz

Bank: Steilkurve oder flache Wand. Gut zum Cruisen

Canting: verändert die Neigung des Fusses längs bzw, quer zum Brett.

Carve: geschnittener Schwung

Cruisen: gemütliches, stressloses herumfahren.

Fakie: Rückwärtsfahren

Gap: Lücke, bzw. Strasse die mit einem Straight Jump übersprungen wird.

Goofy: Fahrerposition, bei der der rechte Fuss in der vorderen Bindung ist.

Grab: Greiffen des Bretts während eines Sprungs.

Leash: Fangleine welche dafür sorgt das das Board nicht abhaut.

Local: Einheimischer

Nose: Boardspitze, Schaufel

Obstacle: künstlich angelegte Hindernisse

Pipe Dragon: Maschine zum Shapen der Halfpipe.

Powder: Snow for heavenly boarding

Regular: Fahrerposition, bei der der linke Fuss in der vorderen Bindung ist.

Sketchy: unsicheres Fahren und Landen von Tricks.

Slam: unkontrollierter Sturz.

Slush: Sulzschnee

Step in: Bindung bei der man die Hände für anderes gebrauchen kann.

Spin: Drehung

Stall: Einen Trick möglichst lange in einer Position halten.

Tail: Heck, Ende des Boards.

Twist: Drehung um die Körperachse.

Toe Turn: Frontside Schwung.

ビックサンの
旅行 BIGSONS TRAVELS

WELL THERES ME -
JAME&S
A 25 YEAR OLD WHITE BOY FROM ENGLAND
(LONDON)

i quit my job last september and decided to go to New York, to skate and other things.
read on and find out what he does as he goes about the world doing other things.

the stories and stuff in this site should be updated regularly as i get the information
together if i'm not out skating or chasing girl. so please try to check it out regularly
if you can be bothered. but if you are doing more interesting stuff rather than sitting
indoors playing computers, then thats cool.

always try to enjoy what your eyes see.

the red line on this timeline show how much information there is on bigson's travels

title **j-buyers.com**

web address **www.obsolete.com/bigson**

design **BIGSON (James Gibson)**

software **bbedit, gifbuilder, illustrator, sound edit, photoshop, premiere**

origin **UK**

type of site **experimental**

work description **an online journal exploring the following: life, time, travel, friends, love, me, loss, living, finding, memory, japan, beer, t-shirts, sneakers, girls, memory-loss, music, artists, toys, food, skating, fun, work, cats, watching, listening, experiment, journal, connections, surviving, learning, walks, badhead, ny, kogal, fish, let's-kiosk, socks, london, do-lager, sense, mums, dads, families, mountains, may peace prevail on earth...**

ICONOgrafica

120 fresh +
progressive
pictograms

CD-ROM
Mac + PC

apply homepage | cd-roms | product order | contents

apply homepage | cd-roms | product order |

title **Iconografica**

web address **www.apply.de/iconografica**

design **Thomas Sokolowski**

design company **Apply Design Group**

software **gifbuilder, photoshop 4.0,
world-wide-web-weaver 2.1**

number of pages **7**

origin **Germany**

type of site **promotion**

work description **a promotional site for the
Iconografica CD ROM**

title **Eroticons**

web address **www.apply.de/eroticons**

design **Thomas Sokolowski,**
Jindrich Novotny

design company **Apply Design Group**

software **gifbuilder, photoshop 4.0,**
world-wide-web-weaver 2.1

number of pages **6**

origin **Germany**

type of site **promotion**

work description **a promotional site for**
the **'Eroticons' CD ROM**

EROTICONS

69 erotic icons

CD-ROM Mac + PC

apply homepage | cd-roms | product order | contents

pages 194-97

title **IO_dencies questioning urbanity**

web address **www.khm.de/people/krcf/IO/**

client **Canon Artlab**

design company **Knowbotic Research (KR+cF)**

software **java, photoshop, real video**

origin **Germany**

type of site **art**

work description **IO_dencies (development '97: Tokyo-Shimbashi) explores the possibilities of intervening and acting in complex urban processes taking place in distributed and networked environments. The site analyzes the forces present in particular urban situations, and offers experimental interfaces for dealing with these force fields. IO_dencies Tokyo was realized with Detlev Schwabe and Artlab Factory, produced by Canon Artlab and the Academy of Media Arts, Cologne, Ministry of Research and Higher Education North Rhine Westfalia. Next interventions are planned in Sao Paulo and Berlin.**

Labor für mediale Strategien
Laboratory for Media-Strategies
mem_brane

TT

LUB

info

KR'F

forum

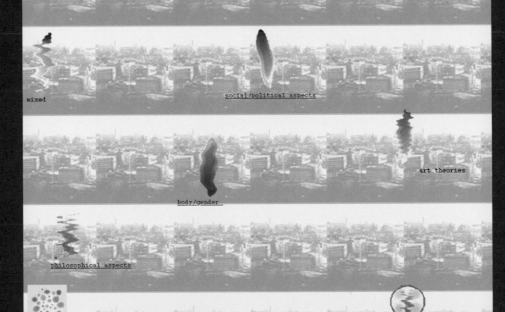

forum mem_brane

'Forum' publishes texts, interviews, essays and disscussions concerning network themes and issues.

'Forum' publiziert Texte, Interviews, Aufsätze und Diskussionen netzwerkrelevanter Themenstellungen.

mixed

social/political aspects

body/gender

art theories

philosophical aspects

discources

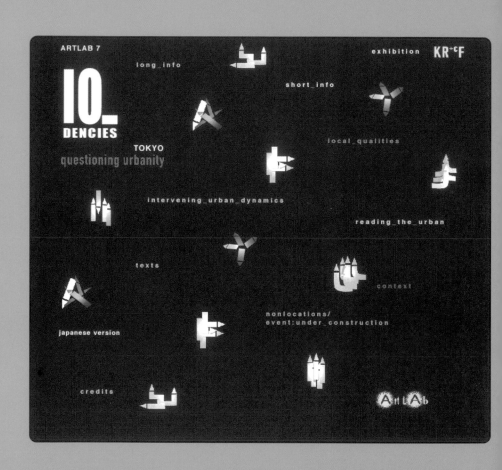

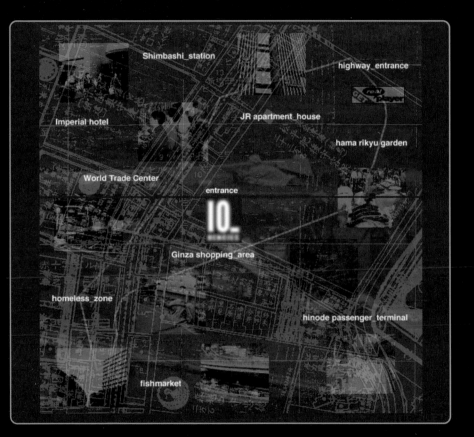

Shimbashi_station

highway_entrance

real player

Imperial hotel

JR apartment_house

hama rikyu garden

World Trade Center

entrance

IO

Ginza shopping_area

homeless_zone

hinode passenger_terminal

fishmarket

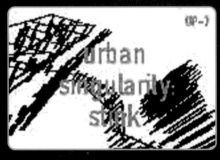

urban singularity: stink

economic effects traffic

title **TYPOTRONIC**

client **The Letterbox and DROM**

design **Stephen Banham,**
Peter Hennessey

design company **The Letterbox**

software **anagram 1.5, director**

origin **Australia**

type of CD ROM **education, promotion**

work description **TYPOTRONIC is an**
interactive type application presented
as a word game; it encourages
people to look at, and recognize
the significance of, their own
typographic environments.

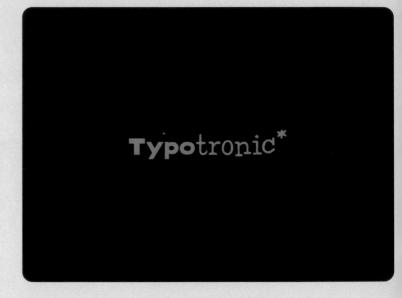

```
200█47.49.3:
200█47.49.3:
204.57.58.133:
204.57.58.133:
20█145.121.23:
pm1-ppp1.flagstaff.azaccess.com:
mugwump.interzone.org:
s191-32.resnet.ucla.edu:
20█145.121.20:
20█145.121.20:
ppp18.artcenter.edu:
20█145.121.20:
20█145.121.20:
20█145.121.20:
194█6.66.244:
194█6.66.244:
194█6.66.244:
193█64.118.18:
193█64.118.18:
194█54.253.10:
193█3.222.84:
194█54.253.10:
194█54.253.10:
196-31-82-211.iafrica.com:
196-31-82-211.iafrica.com:
1v1-mac215.usc.edu:
1v1-mac215.usc.edu:
jgarczev.housing.res.kent.edu:
jgarczev.housing.res.kent.edu:
vkhdsu16.hda.hydro.com:
vkhdsu16.hda.hydro.com:
vkhdsu16.hda.hydro.com:
pool001-max13.mpop2-ca-us.dialup.earthlink.net:
et237.eurotel.sk:
metamedia.v-wave.com:
metamedia.v-wave.com:
pc-34238.bc.rogers.wave.ca:
pc-34238.bc.rogers.wave.ca:
pc-34238.bc.rogers.wave.ca:
210█21.163.73:
210█21.163.73:
210█21.163.73:
```

jodi.org
address **www.jodi.org**
gn **JODI**
ware **color simpletext**
ber of pages **299+**
n **EU**
of site **art**

```
private static final int minimumDownTime      = 15
private static final int sleepTimeDecrement    = 10
private static final int initialPatternLength  = 4:

private Thread   memoryThread;
private int      cellWidth;
private int      cellHeight;
```

INDEX

Page entries refer to captions
(designers and design companies are listed)

DISCLAIMER The information for the captions in this book was supplied by the contributors. Every effort has been made to ensure accuracy, however, the publishers are happy to rectify any errors in future editions.